God is Everywhere – Even In Nursery Rhymes!

Discovering the Depth of the Lord's Presence in Even the Simplest Words

James F. Malerba

Illustrations by Ron Coleman

Cover design by Todd Engel

BookLocker
Saint Petersburg, Florida

Published by BookLocker.com, Inc., St. Petersburg, Florida.

Printed on acid-free paper.

BookLocker.com, Inc.
2020

First Edition

Dedication

I dedicate this work to my late wife of more than 49 years, Dorothy DeGross Malerba, whose unceasing faith in me never wavered, and whose constant encouragement to always believe in myself was a never-ending inspiration for me.

About the Author

James F. Malerba is a writer and editor living in southern Connecticut. He had a 40-year career in the business world and now turns his attention to writing full-length books, such as this work, and is currently researching and writing books on the parables and the gospels and their underlying meanings. He holds a master's degree in Religion from Yale University Divinity School, with a concentration in New Testament Studies. Jim and his wife, Dorothy, raised two children, who are now each raising two children of their own. Life with God is always good!

Table of Contents

Introduction

The nursery rhymes we loved and recited as children, taught to us by our parents, were often our introduction to literature, at a very early age. While we do not usually recite them to ourselves as we grow older, we nonetheless still recall them with great fondness, especially when teaching them to our young children.

Mostly, we read or recite these little gems without giving much thought to whether there are underlying meanings contained in them. After all, they are there to have children not only enjoy them, but also to pass them along years later to their own little ones. This book, which is both for children (to have the nursery rhymes read to them) and adults (to see what messages lie beneath the surface), will uncover God's presence in them.

The impetus for this book came to me suddenly one morning while I was driving home from church. My initial reaction that trying to demonstrate God is present in nursery rhymes seemed far-fetched. After dismissing the idea, it came back to haunt me hours later, so I figured the Holy Spirit was prodding me, and I never argue with God.

I have been a creative writer for decades, but never before had such a possibly wild notion entered into my head. Despite the nagging thought, I mulled over the concept for several days, wondering whether my

1

reasoning was just a quirk or whether I really could delve into the topic and produce logical explanations. The latter won out, and I began to take the initial steps toward writing this book.

The first step was to buy as complete a book of nursery rhymes I could find. From that book I culled more than five dozen nursery rhymes that I felt revealed God's presence.

I have set down the rhyme and then, with explanatory commentaries derived from my research, compared it to companion events or passages in the Bible. Most rhymes have references to the gospels or to other books of the Bible, so you can make a comparison to them and see the correlation between the Bible and how God is present in every rhyme.

Let us begin our journey.

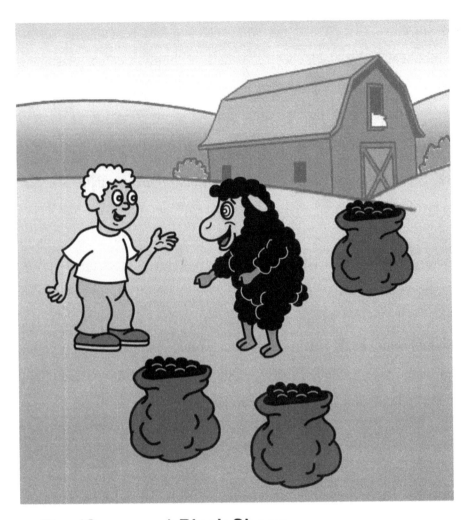

The (Generous) Black Sheep

Black sheep, black sheep,
Have you any wool?
Yes, sir. Yes, sir.
Three bags full.
One for the master,
And one for the dame,
And one for the little boy,
Who lives down the lane.

We all know that rhyme; but what meaning lies beneath the surface? Symbolically, the black sheep is usually a family member or someone else who is being ignored or treated badly because of something he or she has done, or is not welcome for some other reason. This is the person you would not invite to your next party.

This nursery rhyme, however, gives virtually hero status to the black sheep. The other sheep are not asked for their wool, yet the black sheep eagerly shares his wool with three others. There is more than one interpretation to show Divine Presence. First, the number three – for the number of people getting the wool – can represent God (the Master) the dame (the Blessed Mother), and Jesus (the little boy). Also, the wool can represent God's gifts to all – men, women and children. Three bags full would be a lot culled from one sheep, black or otherwise, indicting an unending source of God's love and grace for all.

So, why a sheep at all? Sheep are the gentlest of all animals, trusting and obedient to their human masters. Jesus often used sheep as a metaphor in his preaching. In Matthew (9:36), Jesus pitied the people following him, because they seemed to be spiritually lost – sheep without a shepherd.

Also in Matthew (15:24), when the Canaanite woman begged Jesus to heal her daughter, he told her he was on a mission to serve just the lost sheep of Israel. Of course, Jesus was not cruel and he granted the

woman's wish after testing her faith. This was a lesson for the disciples, who had tried to shoo the woman away.

Jesus used yet another metaphor when he referred to himself as the Good Shepherd (John 10:11). We are all "sheep" and must follow the Good Shepherd into eternal life by our obedience to Him.

Hot Cross Buns (for "Hot" Spirituality)

Hot cross buns, hot cross buns.
One a penny, two a penny, hot cross buns.
If you have no daughters, give them to your sons.
One a penny, two a penny, hot cross buns.

Hot cross buns, sold mostly during the Christian season of Lent, supposedly had their origin in the year 1361. Brother Thomas Rodcliffe of St. Alban's Abbey in Herrtfordshire, England, is said to have developed the recipe for "the Aban Bun", which he gave to the poor on Good Friday.

In 1733, the Oxford English Dictionary referenced hot cross buns and also described them in a way that sounded like a now-familiar rhyme: "Good Friday comes this month, the old woman runs, with one or two a penny hot cross buns" (*from online sources*).

In the Old Testament, There are references, not to hot cross buns, but to their predecessors (raisin cakes). One is found in 1 Samuel (25:9-39). When David sent messengers to honor Nabal, a wealthy but nasty man, and let him know he and his men came to them in peace and in need of sustenance, Nabal screamed at them, rather than welcome the delegation.

Totally abashed, Nabal's wife, Abigail, hastily prepared two hundred loaves of bread (She must had had a huge oven!), wine, dressed sheep, roasted grain, and made two hundred cakes in which there were raisins (figs, in some translations) to feed David and his men. David blessed Abigail for her great generosity, but Nabal did not fare so well. After a drunken night, he fell ill and died ten days later.

Another instance in which raisins had deep meaning is in 2 Samuel (6:1-19). David had just returned the Ark of the Lord to Jerusalem. In

celebration, he gave all his people food, including for each a raisin cake. No one was to go hungry, for David left no one without sustenance.

David's generosity has a parallel to the Eucharist, albeit indirectly. When Jesus fed the five thousand (probably at least triple that, with the uncounted women and children), with just five loaves of bread and two fish, the entire mass of people ate their fill that day (Matthew 14:13-21).

The Lord was sending a message to the disciples, especially, that satisfying the physical hunger would lead to something far more important – satisfying everyone's spiritual hunger, which He revealed at the Last Supper, instituting the Eucharist..

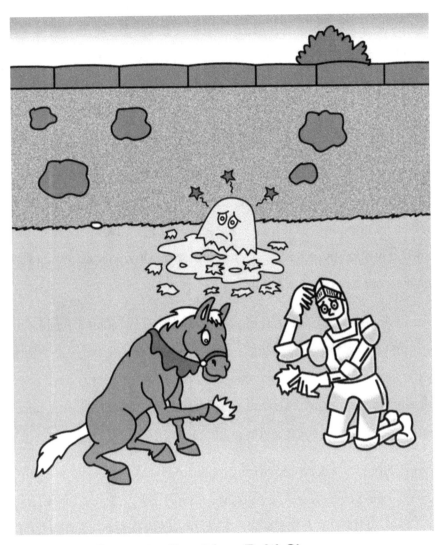

Humpty Dumpty (Lacking Faith?)

Humpty Dumpty sat on a wall.
Humpty Dumpty had a great fall.
All the king's horses and all the king's men,
Couldn't put Humpty together again.

One question we might ask ourselves is whether Humpty Dumpty was the clumsiest "person" on Earth. Most likely, Humpty the egg – as he is usually depicted – fell asleep while sitting on the wall or was distracted, causing himself to fall. Either way, it would not have taken much to shatter him.

The fall, however then led to the concerted efforts of royal lineage to try to fix the poor oaf. Who were those who came to the aid of this unfortunate creature? The king's horses? Really? Not likely that horses would be proficient or have even a rudimentary knowledge of egg repair (if there were even such a thing).

More likely, they would trample on poor Humpty, shattering him into even tinier pieces. The king's men, however, convey a stronger significance for us, for they can be seen as the clergy, who work tirelessly to not only enhance their parishioners' faith, but also to "repair" fallen-away souls and bring them back to God.

Perhaps Humpty chose the wrong path and was comfortable with his decision. His shattering was thus not a physical one, but rather of the spirit. So, the fateful fall Humpty Dumpty experienced can include all people who have suffered an abandoning of faith.

However, spirituality and love of God can always put a person (including Humpty Dumpty) back together again through atonement and a return to faith practices. God is there for us to love him.

All sinners can be saved for the Kingdom by expressing sorrow for all our sins, even in their last hours or moments of life. God, after all, is most forgiving. No more dramatic proof of this is Jesus promising Paradise to the "Good Thief" as he and the Lord hung on crosses (Luke 23:43). Where there is life, there is always hope.

Ring Around the Rosie (Rosary?)

Ring around the rosie,
A pocket full of posies.
Ashes, ashes,
We all fall down.

Ring around the rosie has an interesting opening. Why was there only one rose? Most roses we know are on bushes that produce many blooms, not just one.

Now, picture a rosary. It is oblong, not round (though the beads often are), but when we pray it we go around the beads, or what can be called "little roses". So, the children now can be seen as praying the rosary, or going around its five decades.

But what about the rest of the rhyme? What on Earth does a pocket full of flowers (posies) have to do with it, except to rhyme the first line? Flowers, by their nature, are cherished by almost everyone and serve a number of purposes, from landscaping around homes to romantic gifts for a loved one. And that is one way to explain the pocket full of flowers, for they are being kept by the recipient as a fond memory.

It is in the third line that things become even more curious. Ashes, especially in the Old Testament, symbolized extreme penance, in which penitents sat in them and covered themselves with rough sackcloth.

There are thirty-seven biblical references to ashes, some ritualistic after the slaughter of animals, and others of penance and atonement, usually accompanied by the rending of one's clothes. Tailors and seamstresses in those times must have cheered on such occasions; business was booming!

(Note: A list of references to ashes follows the nursery rhymes in this book.)

In the gospels, Jesus spoke addressed woes to Chorazin, Capernaum and Bethsaida, referring to those unrepentant towns that heard the word of Jesus but did not listen to him, not putting on spiritual sackcloth and ashes in expiation for their sins (Matthew, 11:21-24; Luke 10:13-16).

So, the final line of this rhyme can well be referring to those towns and others other unrepentant people falling down; that is, falling from God's grace. It is possible to see the same theme in the Humpty Dumpty rhyme, with the same fate in the end. Until death, however, sins can always be forgiven. That is a most comforting thought.

One Potato, Two Potato (if You Can Eat Two!)

One potato, two potato,
Three potato, four.
Five potato, six potato,
Seven potato more.

A joke from years ago involved a man picking up a pizza at the pizza parlor. The counterman asked the customer if he wanted the pie cut into six pieces or eight. The man said, "Please – cut it into six pieces – I could never eat eight!"

Not so dissimilar is the rhyme above, which is a bit ungrammatical, because "potato" is never pluralized, but which is also related to God's work on Earth, nonetheless.

In the miracle of the loaves and fish (Matthew 14:13-21; Mark 6:34-44; John 6:1-23), Jesus addressed a huge crowd at length. When he was done, the disciples asked the Lord to dismiss the crowd, so all who had assembled there could buy something to eat, because it was late afternoon. The thousands of listeners had sat there for hours listening to Jesus' profound revelations.

But Jesus had a better idea. When the disciples told Him they had five loaves of bread and two fish, and then complained it was not enough by a longshot to feed such a large crowd, Jesus ignored them and ordered the crowd to sit in groups, then blessed the meager amount of food. In the end, everyone had sated their hunger and there were twelve baskets of leftovers.

How can we relate that event to the nursery rhyme? It is logical to see the counting of potatoes in a similar light. The key is in the final line, "seven potato more." The word "more" implies an infinite number of potatoes, just as the feeding of the five thousand men and the uncounted

number of women and children presaged what was to come at the Last Supper.

In short, the writer of this rhyme was indicating an unending supply of potatoes, and to this day we have an unending source of consecrated Communion Hosts when the priest brings Christ down from heaven with the simple but infinitely powerful words, "This is my Body…This is my blood". It is not a symbolic action; it is actually making Jesus Christ come to us in the Real Presence.

Sippity Sup (What Is Up?)

Sippity Sup, Sippity Sup
Bread and milk from a china cup.
Bread and milk from a bright silver spoon,
Made of a piece of the bright silver moon.
Sippity sup, sippity sup,
Sippity, sippity sup.

One of the most delightful of all nursery rhymes is this one, with its simple and repeated title line. The word "sippity" is a literary device, not an actual known word. It is used today by at least one professional chef and is surely read to children by parents, teachers, and others.

Beyond the unusual word, however, lies what can be interpreted as a reference to the Last Supper, described by Matthew (26:26-28), Mark (14:22-25), Luke (22:14-20), and Paul (1 Corinthians 11:23-26).

When Jesus instituted the Eucharist, he pronounced this incredible miracle in simple words (in Matthew 26:26-28): "Take [the bread] and eat; This is my body." Next, he took the chalice and said, "Drink from this, all of you, for this is my blood of the covenant which will be shed on behalf of many for the forgiveness of sins".

Looking at the sippity sup rhyme, the bread and milk from a china cup can be seen as the Eucharistic bread, while the milk can represent the wine Jesus gave to the disciples at that Passover meal. The silver spoon, made of the bright silver moon is symbolic of the chalice the Lord held and blessed before giving it to the disciples.

Also, the final line of this rhyme is very telling. "Sippity sup" is repeated three times, and the Holy Trinity comprises one God in three Persons.

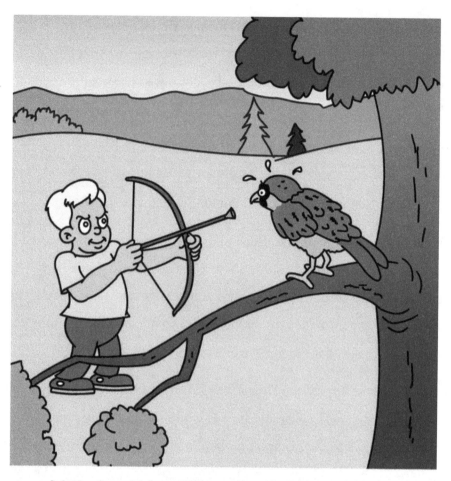

Little (and Very Wise) Cock Sparrow

A little cock sparrow sat on a tree.
Looking as happy as happy could be.
Till a boy came along with a bow and arrow.
Says he, "I will shoot the little cock sparrow."
His body will make a nice, little stew,
And his giblets will make a little pie, too.
Says the little cock sparrow, "I'll be shot if I stay."
So he clapped his wings and then flew away.

There are a few interpretations we can apply to this nursery rhyme. For example, we know a sparrow is a small bird, so what the boy was thinking was very impractical. The boy might try to make a stew out of the sparrow, but it would be in a very small cup. Let's forget the giblet pie, too. Again, those body parts would be impossibly small. So, what are we to conclude?

There is no way to take this rhyme literally. It is fanciful, yes, and has a moral, but it is not about stew and a pie. Let us see the sparrow as a person of faith. He or she is sitting pretty – as the expression goes – because of a strong belief in God, and is gloriously happy to be so. The tree is high, connoting the soaring spirits of the ardent believer. That is why the bird is so happy.

Suddenly, an evil spirit (the boy) shows up near the tree with a bow and arrow. This devil, or possibly even Satan himself, is determined to not only undermine the person's faith, but to end it forever. The arrow (strong temptation) will accomplish his purpose.

But what the devil does not count on is the depth of faith this person possesses. The intended victim is cognizant of the danger of grave sin, so before the evil spirit can fire an "arrow" of great temptation at the believer, he or she says to him or herself, "If I cave in to this really strong temptation, I will commit a serious sin. Yes, it sounds glamorous and is something I might want to do, but my regret later will be stronger than answering this siren call."

Thus, the person overcomes the strength of the temptation and flies happily away from it, leaving the evil spirit to curse his failure.

Butterfly, Butterfly (Flitter and Flutter)

Butterfly, butterfly, flutter around.
Butterfly, butterfly, touch the ground.
Butterfly, butterfly, fly so free.
Butterfly, butterfly, land on me.
Butterfly, butterfly, reach the sky.
Butterfly, butterfly, say goodbye.

Who would not be pleased, even touched by this simple, yet so enjoyable a nursery rhyme? When we read it we can hear a child's innocent voice saying the words and smiling in delight at the end of it. Yet, there is a hint in those words about a butterfly – one of nature's most beautiful creations – that go beyond just the simple enjoyment of reciting it.

Here, we have the metaphor of the Holy Spirit. The Third Person of the Holy Trinity does not flutter around, but he does land on all of us to impart grace and enhance our love of God. The Spirit indeed touches us and also flies free, touching all human souls. We want stronger faith and ask the Spirit to "land on me", because we need to be closer to God.

The last two stanzas introduce what we can see as the Ascension of Jesus Christ. He did indeed reach the sky, as the apostles watched in awe. Luke (24:50-53) wrote, "He then led them out as far as Bethany, raised his hands and blessed them. As he blessed them he parted from them and as taken up into heaven. They did him homage and then returned to Jerusalem with great joy, and they were continually in the temple, praising God."

So, the "butterfly" in those two lines represents the Ascension. The last line, "…say goodbye.", signifies the final Earthly appearance of the Savior, but His presence is with us forever in the form of the Eucharist.

The rhyme also is reminiscent of the innocence of little children, who see butterflies as special creatures. Thus, it harkens back to Jesus'

words: "Truly I tell you, unless you change and become like little children, you will never enter the kingdom of heaven" (Matthew 18:3), and, "Let the little children come to me, and do not hinder them, for the kingdom of heaven belongs to such as these." (Matthew 19:14).

All that is left to say to those most powerful words is, "Amen."

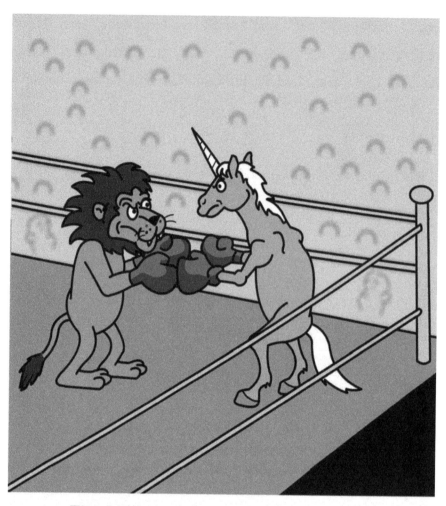

The Lion and the Unicorn
(the Horned and the Unhorned)

The lion and the unicorn were fighting for the crown.
The lion beat the unicorn all around the town.
Some gave them white bread and some gave them brown.
Some gave them plum cake and drummed them out of town.

What are we to make of this rather unusual nursery rhyme? On the surface, it would seem that in real life, even if unicorns existed, the lion would enjoy a good meal, with the unicorn as the entrée, so only the lion would get the crown.

Well, in the fantasy world, all rules are off. What crown were these two animals fighting for? It must have been extremely important, probably for the right to rule the town or even the country.

How do we interpret the line that the lion was beating the unicorn around town? Certainly not a physical fight, or the unicorn would have been the loser, for sure. No, it probably was a race to be the first to reach and claim the royal crown, with the lion the apparent winner..

The crown is the ultimate prize in this frenetic race, that of eternal glory, the ultimate triumph by a person winning the never-ending battle between good and evil. The lion represents the cunning mission of the devil to seduce people into grave sin. The more docile unicorn is Jesus and his quest to bring all to Himself, defeating the devil (the lion) in the unending battle for our souls.

The unicorn also represents the work of the apostles commissioned by the Lord to spread the good news to one and all. At the same time, the lion (devil) races to negate the apostles' preaching and their converting so many to the Faith.

As for the white and brown breads, the white bread represents the Eucharist and the "some" are the priests who consecrate the Host at Mass. The brown bread represents the opposite, with the darkness of the bread emulating the darkness of the sinful soul.

The final line presents us with an enigma, at least for the first half of the sentence. However, the second half relates directly to Jesus, who roused the congregation to venomous anger when he chastised his listeners and cut them to the quick. They seized him and nearly threw him from a high hill. Jesus simply passed through their midst and went on his way, for his time to die had not yet come (Luke 4:16-30).

Similarly, the apostles experienced rejections as they taught the people in the temple. In Acts (4:1-22), the captain of the temple guard and the Sadducees confronted Peter and all apostles with him and hauled them off to the Sanhedrin. There, they all stood their ground and rejected the warning from the Jewish spiritual leaders to stop preaching about the risen Jesus. Instead, it just inspired the apostles to redouble their conversion efforts.

Also in Acts (7:1-60) Stephen, the Church's first martyr, gave an eloquent speech in which he reminded the Jews that the Old Testament leaders, from Joseph to Moses and beyond, suffered much rejection because of the hardened hearts of the Israelites. The Jewish leaders not only refused to listen to Stephen, but also were so incensed that they

stoned him to death. Even as was dying, Stephen begged God to forgive them, just as Jesus did as he was about to be crucified (Luke 23:34).

Watching Stephen die was a young Pharisee named Saul, who approved of Stephen's death. Little did he know, as those about to hurl stones lay down their outer garments at his feet, that he would experience a dramatic conversion by Jesus Himself (Acts 9:1-19), and wrap thousands of men and women into the cloak of faith under his new name – Paul.

Ultimately, both the lion and the unicorn were thrown out of town. Old Testament prophets and leaders, such as Moses, were not listened to by the people and were, in effect, also drummed out of town.

Yet, God's forgiveness is unending, so even the hardest of hearts can be softened by being restored to faith. People of faith are never thrown out of "town" (eternal life) because of their loyalty to God and their good works.

Rain on the Green Grass (Not on a Parade)

Rain on the green grass,
And rain on the tree.
Rain on the rooftop,
But not on me.

Rain can be an annoyance, especially if we want to see a parade, go to a baseball game, have a cookout in the backyard, or whatever other outdoor activities we had planned. But rain, as inconvenient as it can be at times, is also restorative.

When we grow a flower or vegetable garden, rain helps the vegetables or plants grow to their full size. Flowers provide a scenic view we love and which others can admire as they pass by. Gardens provide sustenance by the vegetables we grow.

Rain on the rooftop also gives us comfort, knowing we are protected from the storm and can stay cozy and warm indoors. Sitting by the fire on a rainy day picks up our spirits as we experience the gentle warmth emanating from the fireplace.

The rhyme's last line is our primary focus. While the other parts of this rhyme seem to tell us rain is good for trees, grass and rooftops, having it fall on us is not. So, rain, just in the final line, represents several things. One is that rain dampens spirits at times and can even make us sad.

Also, rain symbolizes the woes and troubles life sends us. A third is that rain represents the temptations we experience, but we resist them and not let them fall on us.

The shelter we seek from rain (sin) is the spiritual shelter a church gives us. There, as the storm of temptation rages helplessly against our shelter, Satan is locked out and cannot enter to harm us.

Itsy Bitsy Spider (Small, but Big in Faith)

Itsy, bitsy spider,
Climbed up the waterspout.
Down came the rain,
And washed the spider out.

Out came the sun,
And dried up all the rain.
Itsy bitsy spider climbed up the waterspout again.

Parents everywhere sing this rhyme, rather than recite it. This is a classic song in the rhyme literature. In real life, spiders are not exactly the most desirable of all God's creations. They are what we call creepy, crawly critters, no matter how big or small.

Here, however, is a different kind of spider. Unlike Little Miss Muffet, who was frightened away from her meal when a spider showed up, there are no humans in this rhyme, just a determined spider.

The itsy bitsy crawler has a big heart filled with determination. It gets wiped off the waterspout and slides or falls to the ground. Undoubtedly, the spider has no shelter nearby and has to ride out the storm, perhaps snuggled into the grass. Then, when the storm ends, this little creature climbs right back up the waterspout. A spider's faith in his or her ability is a wonderful example of unending determination.

Our nursery rhyme hero, the tiny spider, is akin to a person who falls into sin, regrets it sorrowfully, and atones. He or she falls into sin once more, and atones again. We are all flawed human beings, and sin is part of our lives. We climb up the "waterspout" (our faith) by confessing those sins with ever-increased determination and ask for God's grace over and over. God listens, and forgives, over and over.

It is not how many times we fall into sin, but how many times we repent and pick ourselves up spiritually, determined to not repeat those transgressions.

Little Miss Muffet (the Track Star)

Little Miss Muffet,
Sat on a tuffet, eating her curds and whey.
Along came a spider,
Who sat down beside her,
And frightened Miss Muffet away.

Who eats curds and whey these days? Actually, you can find the recipe online and discover it is very simple to make. All you need is milk and vinegar or citrus juice. Doesn't sound like a very scrumptious meal, does it? Who knows? Maybe it has some redeeming social value.

And more, has anyone actually seen a spider sit? Now, that would be interesting for a creature with eight legs.

Unlike the itsy bitsy spider in the preceding nursery rhyme, this spider was more intimidating and Miss Muffet fled the scene, probably leaving bowl and spoon behind in her terror. Here, we might say the little girl was pure of heart, and the evil spider – the devil – came to her and tried to coerce her into sin by his power.

However, Miss Muffett had a deep faith, even for a young child, and fled the devil for safer places – home or a church—where she could thank God for giving her the courage and strength to stand up to sin and temptation and stay in grace through the Holy Spirit.

Three Blind Mice (not Umpires!)

Three blind mice, three blind mice.
See how they run, see how they run.
They all ran after the farmer's wife,
Who chased after them with a carving knife.
Did you ever see such a thing in your life,
As three blind mice.

Back in the 1950s, games at Ebbets Field, home of the Brooklyn Dodgers (now the Los Angeles Dodgers), had a small group of amateur musicians in the stands who were both entertaining and great fan favorites. They called themselves the Brooklyn Symphoney [sic]. When a batter on the opposing team struck out, the band escorted them to the bench with a repetitive tune and then, when the player sat down, hit a discordant note.

One day, the band members took exception to what they thought was a bad call by the umpire. They then started playing "Three Blind Mice." They were told in no uncertain terms they were never to do that again, or face banishment forever.

The rhyme, "Three Blind Mice," is one of the most-read and sung nursery rhymes in the literature. No ballgame is part of this beloved nursery rhyme, but there are subtle messages within those words that bear inspection. Picturing three sightless mice running around wearing sunglasses is laughable, of course, but if we peel away the surface layers we uncover some salient facts.

In both the Old and New Testaments, there are dozens of references to blindness. (*A complete list of references in the Bible to being blind physically or spiritually is at the end of this work.*)

Symbolically, in the gospels, blindness took on a new meaning. An example from Matthew (9:27): "As Jesus went on from there,

two blind men followed him, calling out, 'Have mercy on us, Son of David!'"

A similar cry for help is in Matthew 20:30: Two blind men were sitting by the roadside, and when they heard that Jesus was going by, they shouted, "Lord, Son of David, have mercy on us!"

The most vivid example of Jesus giving the miracle of sight is found in John (9:1-40). It is more dramatic not only for the cure Jesus conferred on the blind man, but also because he did so on the Sabbath. The Pharisees took strong exception to the cure, because Jesus had done so on the Sabbath, calling the Lord a sinner.

When they questioned the formerly blind man, he stood his ground and boldly stated, "Whether he is a sinner or not, I do not know. One thing I do know. I was blind but now I see!"

John (9:39), put an exclamation point as to why Jesus cured blind men: Jesus said, "For judgment I have come into this world, so that the blind will see and those who see will become blind."

That passage in John anchors the meaning of the rhyme, for those who are blind but have faith will see God because of it, and those who lack faith are blind to their shortcomings and possibly not-so-good ways and have turned their backs on faith to embrace the things of the world.

The blind men in Matthew 20:30 knew somehow that Jesus was the Messiah, though they had never seen him or anyone else. This proves that one does not need physical sight to see the path to eternal life.

Speaking of Mice (Mouses?)
Tommy Tittlemouse

Little Tommy Tittlemouse,
Lived in a little house.
He caught fishes,
In other men's ditches.

Sure, mice are small creatures and do not require much space, but it can also be said Tommy was content with the small, humble abode he had, not wanting to live lavishly. He loved to fish, but here things become a bit curious. Who fishes in a ditch? One is not likely to catch anything except junk or discarded items there.

Well, Jesus did not fish in a ditch, nor did the disciples, but they all went fishing in the world of sin (the ditch) to bring the fish (all people) out of the dirty water (sin and evil) and into life in God. When Jesus called Peter and his brother Andrew to discipleship, he "caught" them into the Faith by saying, "Come after me, and I will make you fishers of men" (Matthew 4:19).

The fishing metaphor also surfaces (pun intended) in Luke's version (5:1-11), Simon and his brother Andrew were frustrated, because they had caught nothing and were not going to make any money that day. When Jesus told them to cast their nets, they snagged so many fish that they called for help from James and John, who also were then "caught" into discipleship.

Peter and others on the boat with him were astonished by this miracle, and Peter fell to his knees and blurted out, "Depart from me, Lord, for I am a sinful man" (Luke 5:8). Jesus, however, saw something beyond Peter's admission, and embraced him to later found the Church.

A similar occurrence, and one even more specific in symbolic meaning, is found in John (21:6-12), also involving Peter as well as six other

disciples. Peter told the others he was going fishing, not yet knowing if and when Jesus would return to give them further instructions. As in the earlier accounts by Matthew and Luke, they caught no fish that day.

Then the risen Jesus appeared on the shore and called to the disciples to cast the net. They suddenly pulled in one hundred fifty-three large fish and realized the One who had called out to them was the Lord. Their excitement could not be contained.

The number of fish Peter and the other disciples brought into the boat were all of the known species of fish at that time. Jesus had just, in effect, sent a tacit message to the disciples that all people were to be brought into the Faith, no exceptions.

Mary Had a Little (Loyal) Lamb

Mary had a little lamb,
Whose fleece was white as snow.

And everywhere that Mary went,
The lamb was sure to go.

He followed her to school one day,
That was against the rule.
It made the children laugh and play,
To see a lamb at school.
And so the teacher turned it out,
But still it lingered near.
And waited patiently about,
Till Mary did appear.

"Why does the lamb love Mary so?"
The eager children cry.
"Why Mary loves the little lamb, you know,"
The teacher did reply.

Here is a nursery rhyme with a loving message. Lamb and sheep are the gentlest of animals, trusting and innocent, and they play a critical role in this rhyme and, as we saw in an earlier rhyme, in the gospels. For starters, it is undoubtedly no coincidence that the girl's name is Mary. The Blessed Mother Mary is not directly in the rhyme, but her presence is there, nonetheless, the mother of the lamb, who is the Good Shepherd.

As we know, Jesus referred to sheep numerous times and in John's gospel called himself the Good Shepherd: "I am the Good Shepherd. A good shepherd lays down his life for the sheep" (John 10:11). The "sheep" are all of us. When we worship Jesus and pray to Mary, we are paving our way to eternal life. Mary is a person of faith going to a house of worship (her school), shepherded by the Eternal Lamb with her.

The teacher (evil spirit) does not allow the lamb to stay. That spirit is trying to prevent the faithful person from worshiping God, attempting to prevent Jesus from entering that person's heart.

Mary, however, is determined not to be a victim of sin. This is not lost on her classmates. They wonder why Mary loves Jesus so much, and they answer their own rhetorical question by crying, "Why Mary loves the little lamb, you know."

Those who cry out are others of faith who realize the Lamb, once slain, lives forever in everyone's heart, once they embrace the Son of God.

Birds of a Feather (Avian and Human)

Birds of a feather flock together,
And so do pigs and swine.
Rats and mice will have their choice,
And so will I have mine.

This rhyme demonstrates a clear example of faith, or lack of it. Birds of a feather are those who flock together and are with each other to practice and worship in churches or other houses of prayer. Pigs and swine are those who also flock together to scoff at believers and pooh-pooh people who try to attain a stronger spiritual life.

Most of us have probably met such negative people, but arguing with them accomplishes nothing. Setting the wonderful example of faith practice is the best and strongest message we can send to the naysayers. It can even soften the most hardened hearts.

That is the theme of the last line. Those pigs, swine, rats and mice can go in their direction of godlessness, but the person of faith goes in his or her faithful direction unerringly and in endless joy.

Two Little Dicky Birds (More Than Feathers!)

Two little dicky birds,
Sittiing on a wall.
One named Peter,
One named Paul.
Fly away, Peter,
Fly away, Paul.
Come back, Peter,
Come back, Paul.

Could there be a clearer or more dramatic reference to the missionaries Peter and Paul? After the Resurrection, Peter immediately spread the gospel to one and all, until his execution.

Tradition has it that Peter, condemned to be crucified, said he was not worthy of the cross. He then was crucified upside down. It was another affirmation of his love for Jesus in humbly accepting the same death, but saying he was unworthy of the method.

And Paul, after his spectacular conversion (Acts 9:1-19), became arguably the greatest preaching apostle of all. Ultimately, he lost his life by being beheaded. He was not crucified, as was Peter, because he was a Roman citizen (Acts (22:25-29; 23:27). That empire did not crucify their citizens condemned to death, but rather beheaded them. Death came more quickly to Paul than to Peter, but both received the crown of eternal glory.

The epistles (letters) of both Paul and Peter contain deep spiritual advice and revelations, but also show the hearts of two men totally committed to God. Peter and Paul suffered much for Jesus, but did so more than willingly. Little wonder they are among the greatest saints of the Church.

In this rhyme, when the text tells Peter and Paul to fly away, it is not because they are not wanted, but because God is calling them, through the Holy Spirit, to go out wherever they can to preach the Word and bring thousands into the Faith.

The last two lines underscore this by telling the apostles to return, possibly to Jerusalem, and to know God is giving them the spiritual and temporal direction that they always subsequently shared with everyone to whom they preached and counseled.

The King of France Went Up the Hill
(but Not for Water)

The king of France went up the hill,
With twenty thousand men.
The king of France came down the hill,
And never went up again.

There are two questions here: Did the king come down the hill alone, or did his twenty thousand men come down with him? And, why did they all go up the hill in the first place?

The king is Jesus, who went up the hill to give the Sermon on the Mount (Matthew, chapters 5-7). Of course, he was not accompanied by any soldiers, but that large number with the king can be seen as the huge crowd to whom Jesus addressed at the Sermon on the Mount.

Companion examples are the feeding of the five thousand people (Matthew 14:13-21; Mark 6:34-44; Luke 9:10-17; John 6:1-15), and feeding of the four thousand (Mark 8:1-9)

The soldiers can also be the great number of people Jesus gathered to himself during his life and who, if they became believers, ascended into heaven when they died. Throughout the past two-thousand-plus years, countless numbers of men, women and children were (and are) "soldiers" (martyrs and other faithful people) who lived worthy lives and received great rewards in heaven.

The Queen of Hearts (a Real Card!)

The queen of hearts,
She made some tarts.
All on a summer's day.

The Knave of hearts,
He stole the tarts,
And took them clean away.
The king of hearts called for the tarts,
And beat the knave full sore.

The knave of hearts,
Brought back the tarts,
And vowed he'd steal no more.

In most card games, the queen is over the knave (jack), and the king is over the queen. The king can be seen as God, the queen as the Blessed Mother, and the jack as a grievous sinner.

The tarts are faithful people under the protection of the Blessed mother. The knave (jack) is the devil, whisking people of weaker faith off to indulge in his sinful ways. So, what role does the knave play, other than being a sinner? The answer is in the knave's ultimate repentance.

The knave was cowered by the roaring king, whose promised tarts were stolen from him. Interpreting this, we can conclude the king is chastising the knave as a great sinner who caused others (the tarts) to leave their faith and be seduced by the call of the worldly pleasures.

This rhyme, however, actually ends on a hopeful and positive note. The knave's role is twofold. He is one who steals people's faith, but then he metaphorically represents the repentant person renouncing his sinful ways forever, especially for having led people down the wrong path.

The last stanza could well refer to the "Good Thief", who asked Jesus to forgive him as they both hung on the cross (Luke 23:40-43). Jesus did just that, promising that repentant sinner that he would be in heaven that very day. Sinners can be saved even at the point of death by sincerely asking the Lord for forgiveness.

Girls and Boys Come Out to Play
(in God's Grace)

Girls and boys, come out to play.
The moon will shine as bright as day.
Leave your supper and leave your sleep.
And come with your play friends in the street.
Come with a whoop, come with a call.
Come with a good will or not at all.
Up the ladder and down the way,
A halfpenny will serve us all.
You'll find milk and I'll find flour.
And we'll have pudding in half an hour.

In this nursery rhyme of British origin ("halfpenny" was a British coin), biblical references abound beyond the first couplet, which has children playing out at night. Hmmm... This seems a bit strange. Why would parents let their young children play outdoors at night? Or, maybe it is not so strange, because there is the first hint of God's presence there.

"The moon will shine as bright as day." This is most likely the Eternal Light in the heavenly Kingdom. All darkness is dispelled forever, and the light of God shines on all who inherit heaven.

"Leave your supper and leave your sleep." Again, in God's presence, there is no need for food or sleep. The unending life in heaven is pure joy, when we see God as he is and worship him for all eternity.

The night theme continues when the children are asked to leave their night meal and forgo sleep. They are then instructed to play with their friends in the street.

All the joy children experience at play is symbolic of all people who have lived lives of grace and are forever in the eternal happiness God gives to all the faithful. That is why we all must play in the "street" fervently, for the street represents the path to heaven, and serving God faithfully puts a soul firmly on that path.

Let's call the next couplet that of the Eucharist. The halfpenny roll, surely a very small bit of bread, will never serve all the children who have come out to play. As we saw earlier, Jesus fed a multitude with

just five loaves of bread and two fish. That was a precursor to the Eucharist.

That also can well be applied here. The halfpenny roll will feed everyone, because the miracle of God's presence in bread feeds every soul who believes in Him and who receives the eternal Bread worthily.

Finally, one of the children is told to find milk, while the one giving the order will find flour, and they can then make pudding in half an hour. Substitute water for milk and flour to make bread, rather than pudding, and we have the preparation for the Eucharistic feast.

Polly Flinders (Typical Kid!)

Little Polly Flinders,
Sat among the cinders,
Warming her pretty little toes.
Her mother came and caught her,
Told off her little daughter,
For spoiling her nice, new clothes.

Young children do some interesting things, such as pouring food on themselves, cutting each other's hair, having spats with siblings, and many other behaviors that drive parents to distraction. Both parents and children all laugh later about those seemingly serious episodes that were mostly anything but that. So, Little Polly Flinders was just being a child by sitting in cinders.

Cinders or, more notably, ashes, have biblical significance, especially in the Old Testament. There are dozens of such references, and they range from ritual purification to penance. "Tamar put ashes on her head and tore the ornate robe she was wearing. She put her hands on her head and went away, weeping aloud as she went" (2 Samuel 13:19).

Then, in Esther 4:1-3): "In every province to which the edict and order of the king came, there was great mourning among the Jews, with fasting, weeping and wailing. Many lay in sackcloth and ashes" (mourning ritual over loss of freedom).

Further, in Job 2:8: "Then Job took a piece of broken pottery and scraped himself with it as he sat among the ashes" (lamenting his fate).

Matthew (11:21) and Luke (10:13) both quote Jesus' woe to Chorizan and Bethsaida, warning them they will suffer the same fate as Tyre and Sodom for being unrepentant. Those two towns would have survived had they repented in sackcloth and ashes.

Jonah, after being spewed onto the shore by the big fish (Jonah 2:11), preached destruction to the city of Nineveh for all their sinful doings. This warning spurred the king to declare a fast for humans and animals alike. All, including him, were to sit in sackcloth and ashes in repentance. God then saw the people's repentance and spared the city (Jonah 3:6-10).

In this rhyme, along comes Polly's mother, who is shocked to see her daughter sitting in ashes, though not repenting of anything, just being a child. Unfortunately, her mother does not see it quite that way and chastises poor Polly. She is not upset because Polly did anything wrong, but because she did not use common sense. When we employ our common sense, it always reminds us that doing His will at all times is the way to spiritual happiness.

Rock-a-Bye Baby (a Baby in a Tree?!)

Rock-a-bye baby on the treetop.
When the wind blows, the cradle will rock.
When the bough breaks, the cradle will fall,
And down will come baby, cradle and all.

Whoa! What loving parent puts a baby up in a tree? Yet, this – one of the most enduring nursery rhymes – is sung generation after generation. It is one of the few in which bodily harm is part of the rhyme. But deliberately injuring a baby? That is exactly the heinous act King Herod ordered after the visit by the magi. It resulted in an event far more tragic than a fall from a tree.

When the magi arrived on Jerusalem, they asked about the "newborn king of the Jews (Matthew 2:2). Herod heard about this and summoned the magi to his palace. He then pretended to want to do homage to this child, though his real intent was far more sinister.

After their visit, the magi were warned in a dream not to return to Herod, so they returned to their own country by a different route (Matthew 2:12).

Matthew's gospel depicts the horrendous deed King Herod commanded his soldiers to do when the magi left Bethlehem by another route, not returning to Herod. So furious was that soulless character, he wanted Baby Jesus killed because he saw him as a threat to his power. He immediately ordered the slaughter of all boys two years old and younger in Bethlehem and vicinity (Matthew 3:16).

An ill wind blew when Herod rocked the entire town, because all mothers and fathers were about to lose their precious young ones.

This nursery rhyme is symbolic of the slaughter of the Holy Innocents, who were cut to pieces because of a madman's twisted mind. The bough breaking on the tree is Herod's temper, which was considerable and totally irrational. We see the deaths of those precious children in the last line of the rhyme. It was one of the greatest tragedies in human history.

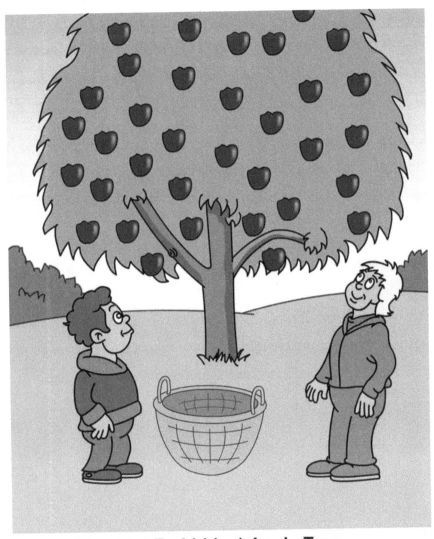

The (Not Forbidden) Apple Tree

Here is the tree with leaves of green.
Here are the apples that hang between.
When the wind blows, the Apples fall.
Here is a basket to gather them all.

As in the cradle rhyme, a wind blows. Unlike that rhyme, this time it is a good wind, not an evil one. A tree with green leaves is about life -- a living person or any other living thing. Green leaves are always a welcome sign that another spring is upon us and our spirits are lifted.

Apples are so much a part of our lives that they are indispensable. We eat them raw, bake them in yummy pies, make applesauce, and so forth. Who is not thrilled by a piece of warm apple beneath a heaping scoop of ice cream? Yes, the apple is yet another symbol of life.

In this nursery rhyme people who have fallen from God's grace are the apples. They have abandoned or lost their spiritual way and are wandering aimlessly through life. But there is hope, for the disciples, clergy and other spiritual leaders are there with a basket to gather them in and bring them back to the Lord's infinite and unending grace.

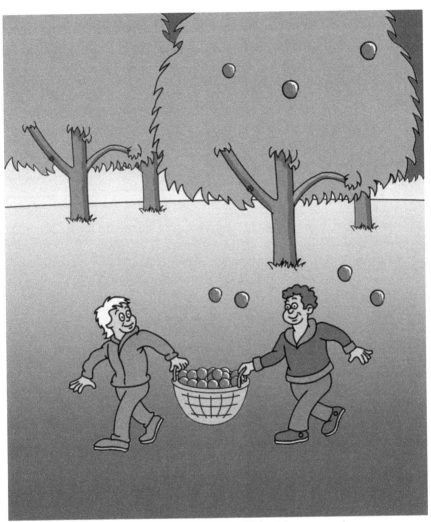

(Speaking of Green, We Have. . .)
Up in the Green Orchard

Up in the green orchard, there is a green tree.
The finest of pippins that you may see.
The apples are ripe and ready to fall,
And Richard and Robin shall gather them all.

As in the previous nursery rhyme, apples are the stars of the show. We can say that the apostles (Richard and Robin) were under the tree, eagerly gathering those "apples" (converts to the Faith) falling onto their waiting arms. Today's spiritual leaders do the same thing for us. Our shepherds lead their flocks unerringly down the path to an eternal reward.

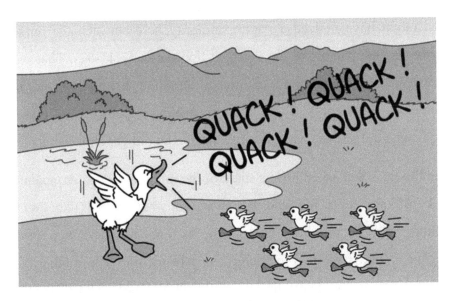

Five Little Ducks (Losing Their Way)

(Note: Because of the length of this nursery rhyme, we will use only the first and last lines, since all four stanzas are identical, except for the number of ducks returning.)

Five little ducks,
Went out one day,
Over the hills and far away.
Mother duck said,
"Quack, quack, quack, quack."

But only four little ducks came back.

(Final stanza follows.)

One little duck,
Went over one day,
Over the hills and far away.
Mother duck said,
"Quack, quack, quack, quack."

And all of the five little ducks came back.

You might have noticed a vague similarity here between the nursery rhyme and the parable of the Prodigal Son (Luke 15:11-32). That well-known parable is a story of greed, dissolute living, sorrow, but, ultimately, forgiveness. There is an underlying, repetitive hint that the ducks who did not one back, one by one, were prodigal children, too.

The Prodigal Son asked for his share of the inheritance and immediately took off, also over hill and far away, to what looked like greener pastures. So did our little ducks. One by one, they left their loving mother to find what they perceived as a better life. The mother duck called out, pleading, every time one of her little ones took off, but each time another one strayed and stayed away.

The mother duck represents the father of the younger son in Jesus' parable, who was constantly looking from a vantage point at his house, hoping and praying the errant lad would come to his senses and return home. His prayers were finally answered, and he embraced his repentant son, weeping and treating him with the greatest love.

We can see the non-returning ducks in the same light. Each was seeking something new and better and not listening to their heads, which were telling them to repent and return to their mother. These ducklings were sinners who turned from God and fell into the siren pleasures of the world. Hope, however, springs eternal, so they finally realized they needed their God and family and returned home to faith and forgiveness.

That last little one who went out was Jesus or one of his disciples, seeking to find those who had strayed from the Faith. From over the hills and far away, a righteous one sought to mend the minds and souls of those who had strayed, and succeeded wonderfully.

The mother duck undoubtedly rejoiced when she saw her brood safely back under her wing, not being angry but rather unequivocally forgiving, despite her little ones' bad decisions. In the Parable of the Prodigal Son, the forgiveness was also instant and unending, despite what sins the son might have committed.

As the father said, "But now we must celebrate, because your brother was dead and has come to life again; he was lost and has been found" (Luke 15:32). Which one of us would not forgive, no matter how much heartache a child has caused us?

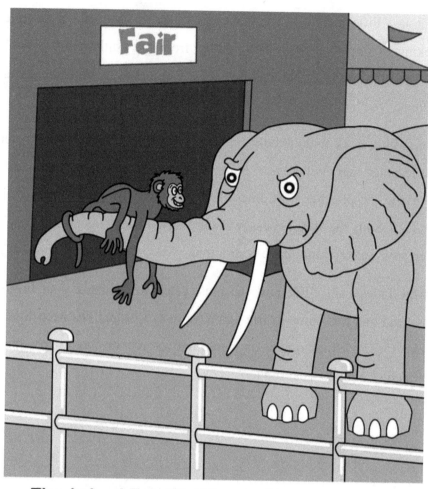

The Animal Fair (Nothing to Sneeze at!)
I went to the animal fair,
The birds and beasts were there.
The big baboon by the light of the moon,
Was combing his auburn hair.

You ought to have seen the monkey,
He jumped on the elephant's trunk.
The elephant sneezed and fell to his knees,
And what became of the monkey ?

In the first stanza, there is the sin of untoward pride in that the baboon was primping and trying to show everyone how superior he was, though he really was just vain. People who are vain often do not care about others, except to want others to say what wonderful people they are. Little wonder pride is one of the seven deadly sins.

Now, being proud is not necessarily sinful. Taking pride in our children and their accomplishments in life (without bragging about them to others) is fine. So is having pride in our doing a good job at work or even in waxing the family buggy, making it shine like new.

What is morally wrong is trying to feel superior to others and not seeing they are just as much God's children as anyone else. The baboon had just that attitude and was guilty of the sin of pride.

Well, what about the monkey? He caused the elephant to sneeze and was crushed when the elephant fell to his knees. Did the monkey commit a serious sin prior to his jumping on the elephant's trunk? We do not know, of course, but there is a hint in that part of the rhyme that a life lived capriciously and not spiritually might well result in a fatal fall from grace.

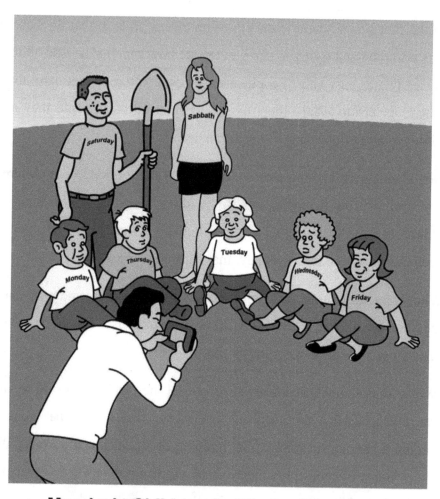

Monday's Child (and a Week of Children)

Monday's child is fair of face.
Tuesday's child is full of grace.
Wednesday's child is full of woe.
Thursday's child has far to go.
Friday's child is loving and giving.
Saturday's child must work hard for a living.
But the child who is born on the Sabbath Day,
Is bonny and blithe and good and gay.

When first written in the 1800s, this nursery rhyme served a dual purpose – to teach little tykes the days of the week, and also try to put some belief into the physical attributes or the emotional aspects related to the particular day of birth. In reality, there is no known correlation between the statements in the rhyme and what children born on those days have assigned to them for life.

Monday's child has no religious or interpretative significance, but Tuesday's child has God's grace, though the rhyme probably relates to social, rather than religious graces. Poor Wednesday's child, who is full of woe, because he or she has either had a difficult life or is regretting many and serious sins.

What to make of Thursday's child? Why does that child have far to go? If we read a spiritual sense into that day, it can be said the child is a nonbeliever who has far to go to be in God's grace, or a convert to the Church who has yet to become eligible for the Sacraments, or perhaps he or she is practicing faith but does not have a solid understanding of it.

Ah, but Friday's child is loving and giving, sharing material things with those who have little Such a person is fulfilling the Corporal Works of Mercy or is a priest, nun or brother, carrying out God's work by ministering to those who are less fortunate in mind, body and spirit.

Saturday's child must work hard to earn money to keep bread on the table and keep his or her family together. This could also mean that

child is struggling to keep children and spouse or even him or herself in communion with the Church.

Well, all comes together for Sunday's child, who has everything going for him or her. That reads as if the child born on the Sabbath lacks for nothing in material terms, but there is more to it than that. This child is grateful for not only having been given the gift of faith, but also the joy that comes with feeling their closeness to God. There is no greater gift for any day's child.

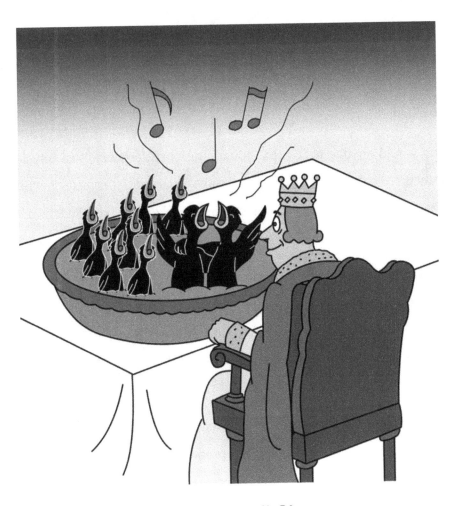

Sing a Song of (at least!) Sixpence

Sing a song of sixpence,
A pocket full of rye.
Four and twenty blackbirds,
Baked in a pie.
When the pie was opened,
The birds began to sing.
Wasn't that a dainty dish,
To set before the king?

It is understandable if you are saying to yourself, "What does this nursery rhyme have to do with God?" You might feel it is a bit of a stretch, but upon closer examination, you can see something implied, not stated.

Why would anyone bake a pie containing birds, especially twenty-four of them? That would have to be some huge pie! Further, the birds survived the oven and even began singing when the pie was cut open. Really? Really!

Twelve of the twenty-four blackbirds can represent the twelve apostles, with the other twelve representing the growth of the faithful in the early Church because of the missions upon which the apostles embarked. Fine, so how do we explain the survival of those birds after being baked alive?

Roman soldiers performed the crucifixion of Jesus, so the baked pie represents his death. But, as Jesus predicted, he would rise from the dead, and so we see in the singing blackbirds the inestimable joy of the Resurrection, as Jesus overcame the tomb and came back to life.

Who is the King? God the Father, who raised His only Begotten Son. The "dainty dish" set before him is both the Resurrection, and the salvation of the human race.

P.S. If you really want "pie", your local "bakery" (church) is offering it this week and every week, through the Sacrament of Reconciliation.. Eat of it spiritually and know you walk with Jesus always.

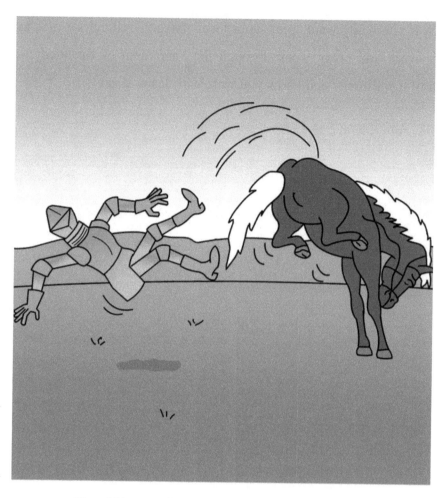

For Want of a Nail
(a Horse Tale? No -- Much More!)

For want of a nail, the shoe was lost.
For want of a shoe, the rider was lost.
For want of a rider, the battle was lost,
For want of a battle, the kingdom was lost.

There is a foreboding progression here, one that tells us a single horseshoe nail can lead to catastrophic consequences. Let's put into the perspective of a person's falling into grave sin, but then repenting.

For want of self-control, grace was lost.

For want of grace, self-worth was lost.

For the want of self-worth, a soul was lost.

For asking for God's forgiveness, sins were forgiven.

For the forgiveness, the soul was saved.

All is never lost if the sinner returns to God.

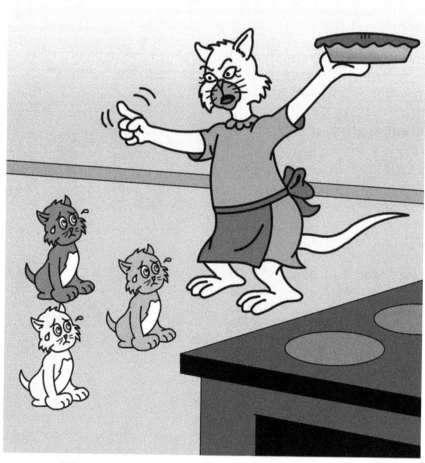

Three Little (and Careless) Kittens

Three little kittens, they lost their mittens.
And they began to cry.
"Oh, Mother dear, we sadly fear.
That we have lost our mittens."
"Lost your mittens? You naughty kittens.
Then you shall have no pie."
"Meow, meow, meow."
"Then you shall have no pie."

"This is Mother Church speaking. You did not lose your mittens; you lost grace by sinning.

"Because you are crying, I know you are sorry for all your sins. So, you naughty 'kittens', the Holy Spirit will lead you to the confessional and once you express sorrow for what you have done, the priest, Christ's representative on Earth, will give you absolution and a penance, and you will find your 'mittens' in a soul that once again is holy and pure."

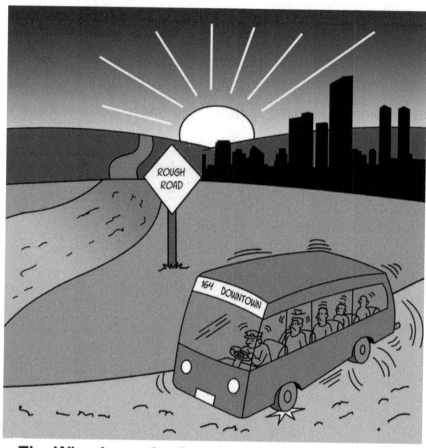

The Wheels on the Bus (to Heaven)

The wheels on the bus go round and round,
Round and round, round and round.
The wheels on the bus go round and round.
All through the town.

(Two verses not directly related to the theme are omitted.)

The people on the bus go up and down,
Up and down, up and down.
The people on the bus go up and down,
All through the town.

Not only do the wheels on the bus go round and round, but so does our planet Earth. On this marvelous creation of God are more than five billion people. Some believe in God, some do not. Some are people of high morals and character, some are not.

The bus is our planet, the people on it are all of humanity. We all go up and down in many ways, from mood variations, to emotions, to different levels of faith practices. And when we go all through the town on this "bus", it is God who is the "bus driver", calling us to Himself. At each infinite stop, people go on and off, meaning some stay with God while others leave the faith.

It is, therefore, much better to ride on the bus all the way than to walk away to a life without God.

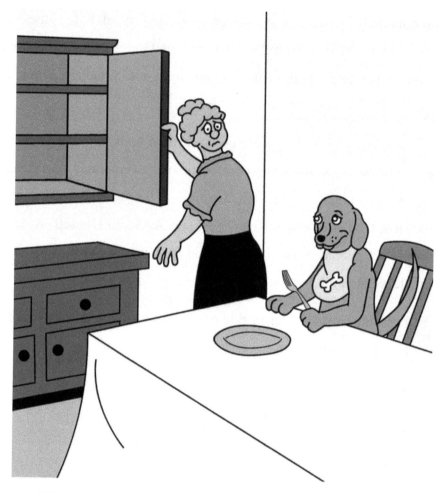

Old Mother Hubbard (and No Bones About It)

Old Mother Hubbard,
Went to the cupboard,
To give her poor dog a bone.
But when she got there,
The cupboard was bare,
And so the poor dog had none.

As we know, dogs love their bones. If you try to take the bone away from a dog chewing on it, you might lose a finger or two. Well, here we have Old Mother Hubbard (God), going to the cupboard of grace, to give it to a poor soul who has fallen from that grace.

Yet, when God opens the cupboard he finds a wanting soul, but one who still is not ready to give up the pleasures of the world and thus gives up on receiving it. A person cannot receive God's loving grace unless the Holy Spirit immerses him or her in it. Then, the "bone" is forgiveness for all sins and is that person's reward.

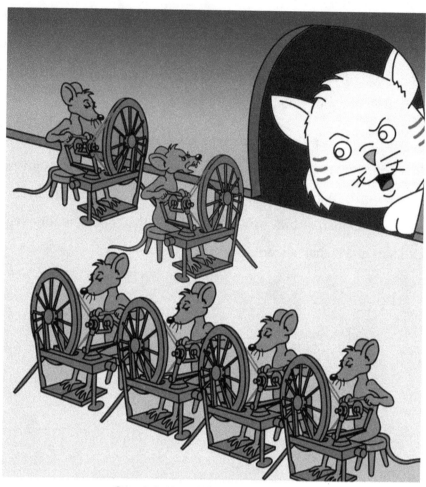

Six Little (Wise) Mice

Six little mice sat down to spin.
Kitty passed by and she peeped in.
"What are you doing, my little men?"
"Weaving coats for gentlemen."
"Shall I come in and cut off your threads?"
""No, no, Miss Kitty, you'd bite off our heads."
"Oh, no, I'll not. I'll help you to spin."
"That may be so, but you can't come in."

Sneaky cat, isn't she? This is Satan in his "best" act of temptation. It is sort of like the big bad wolf in the fairy tale, "Little Red Riding Hood," who pretends to be the girl's grandmother, but really wants to eat her alive.

The wily cat thought she had six suckers who would go along with her so she could feast on them. In life, this would be Satan trying to get people (all the billions) to commit grievous sins, so he could claim their souls.

The virtuous, however, though tempted, and perhaps gravely so, nonetheless reject the siren call, no matter how deliciously it is sugarcoated. "Kitty" (Satan) is thwarted, blinded by the faith of those who have God at the center of their lives. A few minutes or even hours of immoral pleasure are rejected roundly for the true goal of living in the heavenly Kingdom forever, where Satan can never enter and the Holy Trinity is worshipped unceasingly.

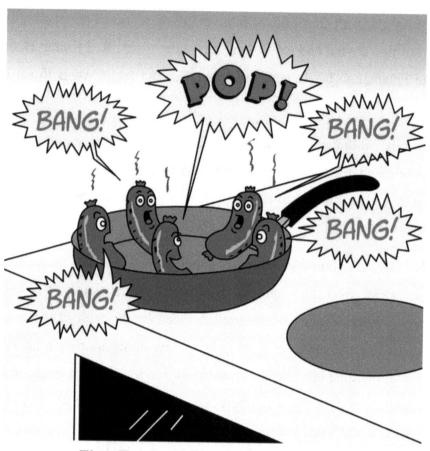

Five Fat (and Tempting) Sausages

Five fat sausages sizzling in a pan,
One went pop and the others went bang.
Four fat sausages sizzling in a pan,
One went pop and the others went bang.
Three fat sausages sizzling in a pan,
One went pop and the others went bang.
Two fat sausages sizzling in a pan,
One went pop and the other went bang.
One fat sausage sizzling in a pan,
One went pop and none went bang.
No fat sausages sizzling in a pan.

One way to look at this rhyme is to see people who are stressed out and go "pop" and "bang". In other words, they are overwhelmed by stress at work or at home, or perhaps are unable to cope with all the problems and issues life hands them.

We can also look at it another way and see five overweight people who go pop and bang with serious health issues caused by their obesity. Sizzling in a pan can mean eating themselves into a shortened life because of gorging themselves at every meal.

Five fat sausages, then four, three, two, one and then none, can be people "fat" in earthly pleasures, from hoarding and not sharing financial riches to engaging in sinful ways, and who pop and bang helplessly when their lives are ended.

But, let us view this rhyme in a more positive note. When "sausages" (people) go pop and bang, we can see it as the enlightening moment when the spiritual lights flash on and he or she turns to God or, if already faithful, even more closely to him. Who has not had such a spiritual moment, usually accompanied by an awestruck feeling and perhaps one of tremendous peace? The "cook", who is God, sends the Holy Spirit into our souls and we embrace more fervently the grace that overcomes us.

There Was an Old Woman Who
Lived in a (Huge) Shoe

There was an old woman who lived in a shoe.
She had so many children she didn't know what to do.
She gave them some soup and slices of bread.
She hugged them and kissed them,
And put them to bed.

(An aside note here: The original version of this nursery rhyme contained the line, "She whipped them all soundly and put them to bed." The revised part is a lot gentler and fits much better into a spiritual interpretation.)

That must have been some shoe, to fit such a large family into it. Little wonder she did not know what to do with so many children! We do know she had little money, giving her children bread and soup and nothing else. And that is the cornerstone of this rhyme.

There are dual messages here. First, and most telling, the bread and soup are symbolic of the Eucharist. At each Mass, a miracle occurs when the priest says the words at the Consecration: "This is my body, which will be given up for you", and, "This is the covenant of my blood, which will be shed for you and for many, for the forgiveness of sins. As often as you do this, do it in memory of me". (Matthew 26:26-29; Mark 14:22-25; Luke 22:17-20; 1 Corinthians 11:23-26).

Now, the old woman, who represents a lack of material goods, also is rich in a much important way. She is the priest who feeds spiritually hungry faithful (the children) the Eucharist. The eternal Bread is forever, unlike material things in the world, which are passing. When we feast at the banquet of Mass, we are fed an immortal "bread and soup" that not only brings us closer to God, but also to an eternal reward.

Come to the Window (and See God)

Come to the window,
My baby with me,
And look at the stars,
That shine on the sea.

There are two little stars,
That play bo-peep.
With two little fish,
Far down in the deep.

And two little frogs,
Cry "Neap, neap, neap."
That should be asleep.

The Blessed Mother, Infant Jesus in her arms, carried him to the window on a starry night, where she sang to him about the stars shining on the sea.

Years later, when Jesus began his ministry, the sea played a prominent role, because the first four disciples were fishermen, who plied their trade on the sea (Matthew 4:18-22; Mark 1:16-20;Luke 5:1-10; John 1:35-42).

And the sea played a role for Jesus in other ways, such as when he walked on water (John 6:16-21), calmed the raging sea (Mark 4:40-41; Luke 8:24-25). So the stars shining on the sea presaged the coming of Jesus to calm the "seas" of anxiety and doubt in people who might not have understood what they were told by the Lord how to attain eternal life.

In the second stanza, two little stars play bo-peep. As we know from another famous nursery rhyme, Little Bo Peep lost her sheep. Similarly, Jesus said he came to Earth to redeem the lost sheep of Israel (Matthew 10:6 and 15:24).

We also see a reference to the gospels in the lines "With two little fish, far down in the deep". When Jesus fed a huge crowd, he took two fish and the five loaves of bread, and performed an incredible miracle (Matthew 14:17-20; Mark, 6:38-43; Luke 9:13-17; and John 6:9-13).

As we know, that feeding of the multitude with a meager supply of food was a forerunner of the Lord's instituting the Eucharist, to feed not just thousands, but billions of believers. Those of faith and good deeds will never be spiritually hungry.

Rub-a-Dub-Dub (in a Big Tub)

Rub-a-dub-dub,
Three men in a tub.
And who you think they be?
The butcher, the baker,
The candlestick maker,
They all sailed out to sea.

First of all, sailing out to sea in a tub might not be the smartest thing to do, but all rules are off in nursery rhymes. Besides that, why three? Why not twelve, as in the number of apostles? Here is one explanation.

The Holy Trinity comprises Father, Son and Holy Spirit; the rhyme comprises a butcher, baker and candlestick maker. Both the rhyme and God's threefold Divine Nature show us three distinct and separate persons.

They also show unbreakable unity. The Trinity is one God; the men in the rhyme are in one tub, also showing unity. Sailing out to sea can be taken as the charge Jesus gave to the disciples in Matthew (28:18-20): "All power in heaven and on earth has been given to me. Go, therefore, and make disciples of all nations, baptizing them in the name of the Father, and of the Son, and of the Holy Spirit, teaching them to observe all I have commanded you. And behold, I am with you always, until the end of the age."

The Apostles were sent into the world (the sea) to build the Faith. We, too, can be modern-day apostles, bringing others to the Faith by the spiritual examples we set and by directly helping friends, loved ones or others who do not worship, to realize the happiness that accompanies believing in the Trinity and God's tremendous love for one and all.

Someone Came Knocking (Let Jesus in!)

Someone came knocking at my wee, small door.
Someone came knocking, I'm sure, sure, sure.
I listened, I opened, I looked to left and right,
But naught was stirring in the still, dark night.

Only the busy beetle tip-tapping on the wall,
Only from the forest the screech-owl's call.
Only the cricket whistling while the dewdrops fall,
So I know not who came knocking at all, at all, at all.

Many artists have depicted Jesus knocking at a closed door, wanting to enter someone's home. All relate to a common theme of acceptance of faith in the Lord. In the above nursery rhyme, the homeowner is sure there is a knock on the door and opens it, but sees no one. The only sounds are from animals of the night; there is no person there.

True, but there is someone there. It is Jesus, knocking and asking to enter the person's soul, enhancing his or her faith, or perhaps the spark of faith, if there was none. The homeowner sees no one, which can mean he or she did not understand the person at the door was Jesus, who wanted to enter his or her soul. Or, perhaps that person heard the gentle call to faith but did not answer it.

On the other hand, not seeing who knocked on the door can also be a positive indication. No one has ever seen God, but he is always there, knocking at our souls and saying, "I love you; you are one of my precious children." We indeed are all His precious children so we must always open the door and let Jesus into our hearts.

Cross Patch (Angry and Gossipy)

Cross patch,
Draw the latch,
Sit by the fire and spin.
Take a cup and drink it up.
Then call your neighbors in.

This rhyme had its origins as early as the 18th century, in England. "Cross" denoted a crabby person; "patch" meant that person also was a gossip or fool. Thus, the rhyme was one designed to make fun of (mostly) older women who were both surly and gossipy.

Here, we find someone who is selfish and, to an extent, reclusive. She (or he) drinks up his or her fill without giving a thought to sharing with anyone else. Only after being sated does this person open the door to others and invite them in.

Conversely, Jesus taught everyone to invite our neighbors into our lives. We are all to gather as one in His name and share our cup of faith unselfishly. To be cross and patch is not the way to live the Golden Rule.

Falling Leaves (God's Grace)

All the leaves are falling down,
Orange, yellow, red, and brown.
Falling softly as they do,
Over me and over you.
All the leaves are falling down,
Orange, yellow, red, and brown.

Rain, snow, and even ice (hail), fall from the sky. But leaves? No, they fall from trees every autumn. Holy "leaves" fall every day; the Holy Spirit "falls" on every human being on Earth. Grace from the Spirit falls on me and you, just as leaves do in our rhyme.

Leaves do not rush downward; they waft gently and harmlessly until they lie on the ground. Even if a shower of them lands on us, there is no damage done. They are too light and soft to cause us pain.

Similarly, the Holy Spirit comes to us, gently guiding us to a moral and ethical way of life. As with leaves, there is no sound when God's grace falls upon us, but our souls are stirred by His love.

The North Wind Doth Blow (Brrr!)

The North Wind Doth Blow,
And we shall have snow,
And what will the poor robin do then,
Poor thing?

He'll sit in a barn,
And keep himself warm,
And hide his head under a wing,
Poor thing.

Most robins are not around in a climate where snow is an annual occurrence. They head for warmer weather, just as human "snowbirds" head for states where winters are warmer.

Perhaps a robin or two might not make the journey south, but the bird is not the message here. Rather, it relates to people trying to hide from God in a place they consider safe, such as behind locked doors or buried in blankets on a cold night.

That is not likely to be very successful, since God is everywhere and sees everything we do or even think. So, like the robin trying to keep warm by hiding his head under his wing, the sinner tries to hide from God.

Bad choice, but not necessarily a fatal one. Just as God is everywhere, seeing all good and not-so-good things we do, so is his forgiveness. We won't find it by hiding, but rather by opening ourselves to him and embracing his love eagerly and in thanksgiving for receiving it.

Baby Dolly (Aren't They All Dollies?)

Hush, baby, my dolly, I pray you don't cry,
And I'll give you some bread and some milk, by and by.
Or perhaps you like custard, or maybe a tart.
Then to either you're welcome, with all my heart.

This rhyme is one of a set of four baby-related rhymes. The others follow immediately. In this first one, we can envision the Blessed Mother humming songs to her Divine Son, who is sleeping peacefully in her arms. There is, however, another way to approach the meaning of this rhyme.

The mother quietly talking to her infant is (in a role reversal) the Son Himself, promising those who accept him that the bread and milk (wine) are the Eucharist that he freely gives to all believers who are in His grace. Of course, there is no custard or tart, but the final line reinforces the fact that Jesus tells us we are welcome to receive the Sacrament and be welcomed by him with all his Sacred Heart.

Babies (All God's Specials)

Come to the land where the babies grow,
Like flowers in the green, green grass.
Tiny babes that sing and crow,
Whenever the warm winds pass,
And laugh at their own bright eyes aglow,
In a fairy looking glass.

Come to the sea where babies sail,
In ships of shining pearl.
Borne to the west by a golden gale,
Of sunbeams all awhirl,
And perhaps a baby brother will sail,
To you, my little girl.

In In what land do babies "grow?" In every land on Earth! There is not a populated place on our planet where babies do not come into the world. This nursery rhyme lets us know that babies are brought to life to "sing and crow" to God after they grow to be understanding and faithful young people. Finally, the baby brother sailing to the little girl is Jesus "sailing" to all of us, asking all to accept Him and live in the peace of faith.

The warm winds being us back to Acts (2:1-4), when the Holy Spirit came from heaven on a strong wind and tongues of fire to settle upon the apostles. The wind filled the house in which the apostles were gathered, but did not harm them. Undoubtedly, though strong in intensity, the wind that day was both warm and gentle, in its own way.

In the second stanza, we are told about ships of shining pearl. The apostles were indeed shining pearls, sent by Jesus to preach to everyone in the world, a charge which continues to this day. "Sunbeams all awhirl" are redolent of the glow in people's souls when they embrace God and faith without question.

Bye, Baby Bunting (Daddy Loves You)

Bye, Baby Bunting,
Daddy's gone-a-hunting,
To get a little rabbit skin,
To wrap my baby bunting in.

Some readers might not approve of a nursery rhyme that mentions a man going hunting for a rabbit to kill and skin. That is understandable, but let us put the rhyme into a biblical perspective. Saint Joseph went hunting not for a rabbit, but for a room at the inn (Luke 2:7). Finding none, he and Mary settled for a stable and a manger within it, and wrapped Baby Jesus in swaddling clothes (the bunting the hunter daddy sought), keeping the Holy Infant snug and warm.

Sleep Baby, Sleep (Please Don't Wake Us!)

Sleep, baby, sleep.
Your father tends the sheep.
Your mother shakes the dreamland tree,
And from it fall sweet dreams for thee.
Sleep, baby, sleep.
Sleep, baby, sleep.

Our final baby-related nursery rhyme brings in another nativity reference. In Luke (2:8-20), the first visitors to the stable were not the local rich people; rather the angel heralded the good news to humble shepherds. Mary, holding her Divine Child, whispered like the leaves falling silently from the tree, cooing baby Jesus to sleep.

Throughout the gospels, sheep and shepherds play a symbolic role. The docile sheep mirrored the gentle Jesus, who lived and died without a single word of complaint, but rather shepherded the disciples and the people in his own wonderful way. The humility of the Holy Family and the shepherds is a lesson in human relations for everyone.

I Had a Little (Soon to Be Abused) Pony

I had a little pony. His name was Dapple Gray.
I lent him to a lady to ride a mile away.
She whipped him, she thrashed him,
She rode him through the mire.
Now I would not lend my poor pony to any lady hire.

If this rhyme recalls the Passion of Jesus, there are indeed elements of it here. Just before he was arrested, tortured and crucified, he made a triumphant entrance into Jerusalem, on an ass lent to the disciples (Matthew 21:1-11); Mark:11:1-11; Luke 19:28-38; John 12:12-19) to fulfill the prophesy of Zechariah (9:9), "See your savior shall come to you; a just savior is he, meek and on an ass, on a colt, the foal of an ass".

Jesus was cheered on by a huge throng, who greeted him as though he were the ancient equivalent of a modern-day rock star. Then, shortly thereafter, he was denounced by the Sanhedrin and by an angry mob as a blasphemer and crucified. But keep in mind it was not the general population who condemned Jesus to death; the Sanhedrin members did so, and incited a riot in Pilate's presence later – probably a hand-picked group of rabble-rousers

So, the little pony symbolizes the ass (colt) on which the Lord rode, and the lady who beat the pony unmercifully represents the torturer who whipped Jesus within an inch of his life. Bringing the pony through the mire represents the way of the Cross. Not lending the poor pony ever again is that, once risen from the dead, Jesus will suffer and die no more. He is risen forever.

The Cock Crows (but to Make Us Wealthy?)

The cock crows in the morn,
To tell us to rise,
And he that starts later,
Will never be wise.

For early to bed,
And early to rise,
Is the way to be healthy,
And wealthy and wise.

Well, this cautionary rhyme promises we will enjoy better health, but to be wealthy and wise? Yes! The early riser is the person who gets out of bed every morning and prays to God to start the day and attends church services on the weekend and perhaps more often. Thus, the person of God is wise in the sense he or she has given top priority not to worldly issues, but to place all in God's hands.

What about becoming wealthy? All who follow the will of God and believe in the Commandments and all the Church teaches are very wealthy, not necessarily in material goods, but rather in spiritual riches. The cock calls the faithful to prayer, just as church bells peal through the morning air and summon us to give yet another day to our Creator.

Little Boy Blue (in Clothes, not Mood!)

Little Boy Blue, come, blow your horn.
The sheep's in the meadow, the cow's in the corn.
Where's the little boy that looks after the sheep?
Under the haystack, fast asleep.

A man, who was an avid golfer, decided to skip going to church one Sunday, telling his wife and family he was ill. Congratulating himself on convincing his family he was too sick to go to church, he headed for the links as soon as they were out of sight going, yes, to church.

On the first tee, he hit a tremendous drive. The ball went right into the cup for a hole-in-one. God and Saint Peter were watching, and Saint Peter was furious. "Lord", he fumed, "He skipped church and you let him get a 300-yard hole-in-one?" God smiled and said, "Yes, but who is he going to tell?"

Now, almost all people who decide to skip Mass or denominational services on a Sunday are not ill, but the message in that little joke has a serious meaning. Avoiding worship might seem like the right decision at the time, but the consequences can be serious. Why put our immortal soul in danger, when worshipping in church provides a person with much more pleasure and happiness, while still leaving the rest of the day to, well, play golf, or enjoy some other leisure-time activity?

While he probably was not a golfer, Little Boy Blue represents anyone who does not take faith or other responsibilities seriously. Shirking off spiritual or other important obligations can never replace the wonderful opportunity to be in God's presence at church or anywhere else. By doing our best at worship, work, home or helping others in various ways, we receive great happiness and spiritual riches in life.

Dame Trot (She Didn't!)

Dame Trot and her cat,
Led a peaceable life,
When they were not troubled,
With other folks' strife.
When Dame had her dinner,
Pussy would wait,
And it was sure to receive,
A nice piece from her plate.

Of all the rhymes that we have studied here, this is the first one that presents us with a stark reminder to love and help others, fulfilling the spirit of human acts of mercy. Dame Trot was content with the life she and her cat led, with no anxiety to disrupt their existence. Fine. No one wants anything less than peace and happiness.

In the second couplet, however, we see a disturbing parallel between this peaceable woman and her attitude toward the woes of the world outside her home. In Luke's gospel (16:19-31), the parable of Lazarus and the rich man has a very similar theme. Lazarus, the beggar, was dirt poor, while the rich man lived in the lap of luxury and did not care about anyone but himself and possibly his rich friends. When both died, Lazarus went to eternal life, and the non-caring rich man suffered eternal punishment.

This apathetic attitude is not at all what Jesus asks of us. Not caring about others is possibly the worst human trait, as the rich man found out when he died and was consigned to hell.

Dame Trot might not have been a bad person, but she did not seem to care about the trials and tribulations of others. She and the cat ate their fill every day, not concerned about those who might be going to bed hungry.

This rhyme, therefore, is a caution to us as Christians to not only be aware of the plight of others, but also to give them a hand up and help

ease their dire need. Helping others makes us so much happier and fulfilled. It is the best way to act in life.

(Vengeful?) Goosey, Goosey, Gander

Goosey, goosey, gander,
Where shall I wander?
Upstairs and downstairs,
And in my lady's chamber.
There I met an old man,
Who would not say his prayers.
I took him by the left leg,
And threw him down the stairs.

Perhaps the first question you might want to ask is, what was an old man doing in the lady's bedroom? Because of this, the rhyme is not easy to interpret, but let's push forward and see what lies beneath the surface.

One might assume the man was there for lustful purposes, and that is why he did not say his prayers. Or, he might have been married to the lady, so being in her (their?) chamber would be aboveboard. Why, however, did the old man not say his prayers? Was he spiritually lazy? Did he not have a strong faith?

We have a plausible answer in the final two lines. The gander – who must have been quite strong! – grabbed his left leg and threw him down the stairs.

Hmmm... There seems to be a similarity between this rhyme and preceding one, where eternal punishment awaits those who shun God or do not lift a hand to help others. Our gander (God) loves us all, but those who do not love back were warned by Jesus that they will pay the full price for their wanton behavior.

In Matthew (25:31-46) the Lord preached about the separation at the last judgment of the sheep from the goats. The "sheep" will be the just, and the "goats" will be the unjust. The sheep will enter into eternal life, while the goats will be thrown down the "stairs" (away from heaven forever) and into the netherworld. That is why it is so important to lead a just life and to pray always, and in all ways!

Oranges and Lemons (Don't Compute)

"Oranges and lemons, " say the bells of St. Clemons.
"You owe me five farthings," say the bells of St. Martin's.
"When will you pay me?" say the bells of Old Bailey.
"When I grow rich," say the bells of Shoreditch.
"When will that be?" say the bells of Stepney.
"I do not know," says the great bell at Bow.
"Here comes a candle to light you to bed.
Here comes a chopper to chop off his head."

Some unknown persons, disguised as bells of churches in England, engage in what appears to be a nonsense conversation. This being a nursery rhyme, the author was able to use church and other bells to place the rhyme, except for the final two lines, into a spiritual meaning.

St. Clements, St. Martins and St. Stepney are indeed churches in various places in London. Old Bailey and Shoreditch are criminal courthouses. Bow is simply the East End of London. The interpretation here lies in a combination of places for salvation and places where evil is punished. Thus, the bells of the three churches peal their call, inviting all people to worship at them and save their souls, while the two criminal courts are the eternal punishment places for unrepentant sinners.

Matthew (25:31-46) contains the explicit words of Jesus regarding the salvation or condemnation of all. The just, who help others and led chaste lives, will be granted eternal happiness. Conversely, those who ignore others and think only of themselves and their own wants, will be condemned to eternal damnation.

The poet, John Donne, perhaps said it best in his work, "Devotions Upon Emergent Occasions, Meditation XVII," where he wrote: "Perchance he for whom this bell tolls may be so ill, as that he knows not it tolls for him; and perchance I may think myself so much better than I am, as that they who are about me, and see my state, may have caused it to toll for me, and I know not that.

"No man is an island, entire of itself; every man is a piece of the continent, a part of the main. If a clod be washed away by the sea, Europe is the less, as well as if a promontory were, as well as if a manor of thy friend's or of thine own were: any man's death diminishes me, because I am involved in mankind, and therefore never send to know for whom the bells tolls; it tolls for thee."

Both the bells in the rhyme and in John Donne's Devotions could not be clearer about the right path that will lead to eternal life.

Little Jack Horner (a Young Believer)

Little Jack Horner sat in the corner,
Eating a Christmas pie.
He put in his thumb,
And pulled out a plumb,
And said, "What a good boy am I."

First off, we might conclude Jack Horner had poor table manners. He not only ate the pie in a corner, not at table, but also ate with his fingers, specifically his thumb.

That aside, to Jack Horner and to all of us, Christmas is one of the most special days of the year. Notice the word for Christmas pie is "a", not "the". It lets us infer there were more pies or other desserts. It also might be reasoned that Jack's parents baked the pie just for him, so he was not being greedy.

The word "plum" has meanings, usually positive, in real life. For example, someone lands an extraordinary job and calls it a "plum" position. In Jack's case, the plum was his finding faith. Indeed, he had also found the Source of all salvation. He was one with Jesus. So, it was a "plum" (spiritual) moment for him.

All of us have "plum moments" when we take the Eucharist at Mass. No fruit or any other food can equal receiving Jesus.

Twinkle, Twinkle Little Star (Our Wonderment)

Twinkle, twinkle, little star,
How I wonder what you are.
Up above the world so high,
Like a diamond in the sky.
Twinkle, twinkle, little star,
How I wonder what you are.

Wolfgang Amadeus Mozart was a serious composer, but he also enjoyed lighter moments. His variations in C Major on the French Song: "Ah vous dirai-je, Maman"("Ah, will I tell you, Momma") K.265 for the piano, later became the famous tune we know as Twinkle, Twinkle Little Star. The same tune also is used in the "Alphabet Song."

Stars have always fascinated us, for they demonstrate the vastness of the universe and are a sobering and awesome reminder of God's existence and omnipresence. So, the writer of this nursery rhyme takes the role of a person – young or older – who is in awe of the heavens. Stars, of course, do not twinkle; that is a result of Earth's atmospheric "interference", if you will. Nonetheless, the twinkling fascinates all of us and has forever.

"How I wonder what you are" is a question not to a star, but to God. That is the kind of curiosity innate in every human being. We might as well say, "Who and what are you, God?"

The answer is not easy, because God, the infinite Creator, will reveal Himself only when He calls us home to the Eternal Kingdom. Meanwhile, our faith in God can continue to manifest itself in the fascination of the twinkling star, whether it is little or big. Such a wonderful object serves as a reminder of the vastness of our universe and God's infinite vastness, as well.

Starlight, Star Bright (Please Shine on Me)

Starlight, star bright,
The first star I see tonight.
I wish I may, I wish I might,
Have the wish, I have tonight.

Wishing upon a star is an age-old saying, and while your stated wish might not be granted, it is always nice to have a fantasy. It is one of the things that makes our lives more interesting and, in a way, more joyous.

This nursery rhyme is beautiful in its simplicity. By looking heavenward, we are seeking God. By seeing the first star we are then seeing the magnificent creation of the vast universe. So, wishing upon a star is fine, but the more important value is that the endless heavens reinforce our belief in God, making our prayer life so much more meaningful.

There Were Ten in the Bed (Some Bed!)

(Note: This rhyme is very long and repetitive in every verse, so we will truncate it to the first and last two verses.)
There were ten in the bed and the little one said,
"Roll over, roll over."
So they all rolled over and one fell out.
(Penultimate and final verses)
There were two in the bed and the little one said,
"Roll over, roll over."
So they all rolled over and one fell out.

There was one in the bed and the little one said,
"Goodnight."

In real life, we all fall out of God's grace occasionally. Substitute Satan for the "little one" in this rhyme and we have the heinous influence of evil, the temptations we face every day. If our faith remains strong, we do not fall out of the "bed" (faith). However, if we cave into sin and temptation, the devil has scored a victory.

The devil says "Goodnight" and chortles over having succeeded in influencing people to rolling over into sin. The better news is that, through the Sacrament of Reconciliation and expressing sorrow for our sins in other ways, God is the victor for the salvation of our souls, and the "bed" of heaven awaits.

Good Night, Sleep Tight
(God Watches Over Us)

Good night, sleep tight.
Wake up bright,
In the morning light,
To do what is right,
With all your might.

"Now I lay me down to sleep, I pray the Lord my soul to keep…" How often did we recite that prayer to our little ones until they learned the verse themselves? While this rhyme is an urging to children to be good, it is just as easily applicable to all adults. We ask for a good night's sleep, say our prayers, and look forward to waking up in the morning to another bright and fruitful day.

The final two lines are reflective of the Ten Commandments, the cornerstones for telling us what we are to do that is pleasing to God every day of our lives. More, we are to do right with all our heart and soul, give service to others, and attend church as often as we can. Those acts keep us in God's grace and also inspire others to do the same things.

(An appropriate finale to our spiritual journey of finding God in nursery rhymes follows.)

If All The Seas Were One Sea

If all the seas were one sea, what a great sea that would be.
And if all the trees were one tree, what a great tree that would be.
And if all the axes were one axe, what a great axe that would be.

And if all the men were one man, what a great man that would be.
And if the great man took the great axe and cut down the great tree,
And let it fall into the great sea, what a splish-splash that would be.

What we have here is not a nursery rhyme in the true sense, but rather a guide to peace in the world under the guidance of God, his Divine Son, and the grace of the Holy Spirit, leading us at all times into deeper faith and good works. This poem provides a set of "rules for the road" for every person, young or old.

The theme, of course, is human unity – many ethnicities, one human spirit, coming together in love, respect, and dignity for one and all. Saint Paul set the standard for all when he said: "There is neither Jew nor Gentile, neither slave nor free person, nor is there male and female, for you are all one in Christ Jesus" (Galatians 3:28).

The tree in the rhyme is both a symbol of might and also one of hope for human unity. The "great man" (Jesus) came into the world to wield his "axe" against sin, toppling it and also solidifying all of us as children of God. The tree, then, symbolizes the defeat of Satan and his angels, and the subsequent unification of the entire human race in peace and worship.

Yes, when we can all come together as one body in Christ, what a splish-splash that would be!

A final Word

Writing and researching in the Bible and other sources for this work was both a challenge and a journey of discovery. At one point, I questioned as to whether I was doing the right thing, seeking to point to God's presence in nursery rhymes. So, I read and reread every one I had selected.

I feel I opened my own eyes to a deeper meaning in the rhymes discussed in this work as I studied them and looked between the lines, so to speak. It is my fondest hope that you, the reader, will do the same and come away with a deeper understanding of the Lord's omnipresence in our existence.

Further, reading these gems to your children, grandchildren or other young folks and explaining them in terms they will understand, might well lead them to a closeness with God today, tomorrow and for the rest of their lives.

God's love and grace be with you always.

Lists for Reference (Ashes and Blindness)

Ashes

There are thirty-seven references to ashes in the Bible, mostly in the Old Testament, and virtually all denoting a negative situation. Even references to ashes that Jesus, the author of Hebrews and Peter's second letter used were woes to the people who sinned and did not repent. Note especially that many Old Testament references to ashes were related to ritual cleanliness, as well as to being penitential.

Genesis 18:27

Then Abraham spoke up again: "Now that I have been so bold as to speak to the Lord, tho*ugh I am nothing but dust and ashes,

Exodus 27:3

Make all its utensils of bronze—its pots to remove the ashes, and its shovels, sprinkling bowls, meat forks and firepans.

Leviticus 1:16

He is to remove the crop and the feathers and throw them down east of the altar where the ashes are.

Leviticus 4:12

that is, all the rest of the bull—he must take outside the camp to a place ceremonially clean, where the ashes are thrown, and burn it there in a wood fire on the ash heap.

Leviticus 6:10

The priest shall then put on his linen clothes, with linen undergarments next to his body, and shall remove the ashes of the burnt offering that the fire has consumed on the altar and place them beside the altar.

Leviticus 6:11

Then he is to take off these clothes and put on others, and carry the ashes outside the camp to a place that is ceremonially clean.

Numbers 4:13

"They are to remove the ashes from the bronze altar and spread a purple cloth over it.

Numbers 19:9

"A man who is clean shall gather up the ashes of the heifer and put them in a ceremonially clean place outside the camp. They are to be kept by the Israelite community for use in the water of cleansing; it is for purification from sin.

Numbers 19:10

The man who gathers up the ashes of the heifer must also wash his clothes, and he too will be unclean till evening. This will be a lasting ordinance both for the Israelites and for the foreigners residing among them.

Numbers 19:17

"For the unclean person, put some ashes from the burned purification offering into a jar and pour fresh water over them.

2 Samuel 13:19

Tamar put ashes on her head and tore the ornate robe she was wearing. She put her hands on her head and went away, weeping aloud as she went.

1 Kings 13:3

That same day the man of God gave a sign: "This is the sign the Lord has declared: The altar will be split apart and the ashes on it will be poured out."

1 Kings 13:5

Also, the altar was split apart and its ashes poured out according to the sign given by the man of God by the word of the Lord.

2 Kings 23:4

The king ordered Hilkiah the high priest, the priests next in rank and the doorkeepers to remove from the temple of the Lord all the articles made for Baal and Asherah and all the starry hosts. He burned them outside Jerusalem in the fields of the Kidron Valley and took the ashes to Bethel.

Esther 4:1

[Mordecai Persuades Esther to Help] When Mordecai learned of all that had been done, he tore his clothes, put on sackcloth and ashes, and went out into the city, wailing loudly and bitterly.

Esther 4:3

In every province to which the edict and order of the king came, there was great mourning among the Jews, with fasting, weeping and wailing. Many lay in sackcloth and ashes.

Job 2:8

Then Job took a piece of broken pottery and scraped himself with it as he sat among the ashes.

Job 13:12

Your maxims are proverbs of ashes; your defenses are defenses of clay.

Job 30:19

He throws me into the mud, and I am reduced to dust and ashes.

Job 42:6

Therefore I despise myself and repent in dust and ashes."

Psalm 102:9

For I eat ashes as my food and mingle my drink with tears

Psalm 147:16

He spreads the snow like wool and scatters the frost like ashes.

Isaiah 33:12

The peoples will be burned to ashes; like cut thornbushes they will be set ablaze."

Isaiah 44:20

Such a person feeds on ashes; a deluded heart misleads him; he cannot save himself, or say, "Is not this thing in my right hand a lie?"

Isaiah 58:5

Is this the kind of fast I have chosen, only a day for people to humble themselves? Is it only for bowing one's head like a reed and for lying in sackcloth and ashes? Is that what you call a fast, a day acceptable to the Lord?

Daniel 9:3

So I turned to the Lord God and pleaded with him in prayer and petition, in fasting, and in sackcloth and ashes.

Amos 2:1

This is what the Lord says: "For three sins of Moab, even for four, I will not relent. Because he burned to ashes the bones of Edom's king,

Malachi 4:3

Then you will trample on the wicked; they will be ashesunder the soles of your feet on the day when I act," says the Lord Almighty.

Matthew 11:21

"Woe to you, Chorazin! Woe to you, Bethsaida! For if the miracles that were performed in you had been performed in Tyre and Sidon, they would have repented long ago in sackcloth and ashes.

Luke 10:13

"Woe to you, Chorazin! Woe to you, Bethsaida! For if the miracles that were performed in you had been performed in Tyre and Sidon, they would have repented long ago, sitting in sackcloth and ashes.

Isaiah 61:3

and provide for those who grieve in Zion— to bestow on them a crown of beauty instead of ashes, the oil of joy instead of mourning, and a garment of praise instead of a spirit of despair. They will be called oaks of righteousness, a planting of the Lord for the display of his splendor.

Jeremiah 6:26

Put on sackcloth, my people, and roll in ashes; mourn with bitter wailing as for an only son, for suddenly the destroyer will come upon us.

Jeremiah 31:40

The whole valley where dead bodies and ashes are thrown, and all the terraces out to the Kidron Valley on the east as far as the corner of the Horse Gate, will be holy to the Lord. The city will never again be uprooted or demolished."

Ezekiel 27:30

They will raise their voice and cry bitterly over you; they will sprinkle dust on their heads and roll in ashes.

Ezekiel 28:18

By your many sins and dishonest trade you have desecrated your sanctuaries. So I made a fire come out from you, and it consumed you, and I reduced you to ashes on the ground in the sight of all who were watching.

Hebrews 9:13

The blood of goats and bulls and the ashes of a heifer sprinkled on those who are ceremonially unclean sanctify them so that they are outwardly clean.

2 Peter 2:6

if he condemned the cities of Sodom and Gomorrah by burning them to ashes, and made them an example of what is going to happen to the ungodly;

Blindness

Whether in either the Old or NewTestament, blind and blindness are seen as everything from punitive to an opportunity (in Jesus' case) to perform a miracle. There are ninety-seven references to this. As you look through them, note how many times blindness is used as a metaphor for not physical blindness, but in regard for those not seeing God's truth and way to salvation. Such is especially telling in the gospels, particularly when Jesus cured the blind on the Sabbath, a symbolic and also stern lesson to the Pharisees and other Jewish leaders that God's mercy never rests.

Genesis 19:11

Then they struck the men who were at the door of the house, young and old, with blindness so that they could not find the door.

Exodus 4:11

The Lord said to him, "Who gave human beings their mouths? Who makes them deaf or mute? Who gives them sight or makes them blind? Is it not I, the Lord?

Exodus 23:8

"Do not accept a bribe, for a bribe blinds those who see and twists the words of the innocent.

Leviticus 19:14

"'Do not curse the deaf or put a stumbling block in front of the blind, but fear your God. I am the Lord.

Leviticus 21:18

No man who has any defect may come near: no man who is blind or lame, disfigured or deformed;

Leviticus 22:22

Do not offer to the Lord the blind, the injured or the maimed, or anything with warts or festering or running sores. Do not place any of these on the altar as a food offering presented to the Lord.

Deuteronomy 15:21

If an animal has a defect, is lame or blind, or has any serious flaw, you must not sacrifice it to the Lord your God.

Deuteronomy 16:19

Do not pervert justice or show partiality. Do not accept a bribe, for a bribe blinds the eyes of the wise and twists the words of the innocent.

Deuteronomy 27:18

"Cursed is anyone who leads the blind astray on the road." Then all the people shall say, "Amen!"

Deuteronomy 28:28

The Lord will afflict you with madness, blindness and confusion of mind.

Deuteronomy 28:29

At midday you will grope about like a blind person in the dark. You will be unsuccessful in everything you do; day after day you will be oppressed and robbed, with no one to rescue you.

2 Samuel 5:6

[David Conquers Jerusalem] The king and his men marched to Jerusalem to attack the Jebusites, who lived there. The Jebusites said to

David, "You will not get in here; even the blind and the lame can ward you off." They thought, "David cannot get in here."

2 Samuel 5:8

On that day David had said, "Anyone who conquers the Jebusites will have to use the water shaft to reach those 'lame and blind' who are David's enemies." That is why they say, "The 'blind and lame' will not enter the palace."

2 Kings 6:8

[Elisha Traps Blinded Arameans] Now the king of Aram was at war with Israel. After conferring with his officers, he said, "I will set up my camp in such and such a place."

2 Kings 6:18

As the enemy came down toward him, Elisha prayed to the Lord, "Strike this army with blindness." So he struck them with blindness, as Elisha had asked.

Job 9:24

When a land falls into the hands of the wicked, he blindfolds its judges. If it is not he, then who is it?

Job 29:15

I was eyes to the blind and feet to the lame.

Psalm 146:8

the Lord gives sight to the blind, the Lord lifts up those who are bowed down, the Lord loves the righteous.

Isaiah 29:9

Be stunned and amazed, blind yourselves and be sightless; be drunk, but not from wine, stagger, but not from beer.

Isaiah 29:18

In that day the deaf will hear the words of the scroll, and out of gloom and darkness the eyes of the blind will see.

Isaiah 35:5

Then will the eyes of the blind be opened and the ears of the deaf unstopped.

Isaiah 42:7

to open eyes that are blind, to free captives from prison and to release from the dungeon those who sit in darkness.

Isaiah 42:16

I will lead the blind by ways they have not known, along unfamiliar paths I will guide them; I will turn the darkness into light before them and make the rough places smooth. These are the things I will do; I will not forsake them.

Isaiah 42:18

[Israel Blind and Deaf] "Hear, you deaf; look, you blind, and see!

Isaiah 42:19

Who is blind but my servant, and deaf like the messenger I send? Who is blind like the one in covenant with me, blind like the servant of the Lord?

Isaiah 43:8

Lead out those who have eyes but are blind, who have ears but are deaf.

In Context | Full Chapter | Other Translations

Isaiah 44:9

All who make idols are nothing, and the things they treasure are worthless. Those who would speak up for them are blind; they are ignorant, to their own shame.

Isaiah 56:10

Israel's watchmen are blind, they all lack knowledge; they are all mute dogs, they cannot bark; they lie around and dream, they love to sleep.

Isaiah 59:10

Like the blind we grope along the wall, feeling our way like people without eyes. At midday we stumble as if it were twilight; among the strong, we are like the dead.

Jeremiah 31:8

See, I will bring them from the land of the north and gather them from the ends of the earth. Among them will be the blind and the lame, expectant mothers and women in labor; a great throng will return.

Lamentations 4:14

Now they grope through the streets as if they were blind. They are so defiled with blood that no one dares to touch their garments.

Amos 5:9

With a blinding flash he destroys the stronghold and brings the fortified city to ruin.

Zephaniah 1:17

"I will bring such distress on all people that they will grope about like those who are blind, because they have sinned against the Lord. Their blood will be poured out like dust and their entrails like dung.

Zechariah 11:17

"Woe to the worthless shepherd, who deserts the flock! May the sword strike his arm and his right eye! May his arm be completely withered, his right eye totally blinded!"

Zechariah 12:4

On that day I will strike every horse with panic and its rider with madness," declares the Lord. "I will keep a watchful eye over Judah, but I will blind all the horses of the nations.

Malachi 1:8

When you offer blind animals for sacrifice, is that not wrong? When you sacrifice lame or diseased animals, is that not wrong? Try offering them to your governor! Would he be pleased with you? Would he accept you?" says the Lord Almighty.

Matthew 9:27

[Jesus Heals the Blind and the Mute] As Jesus went on from there, two blind men followed him, calling out, "Have mercy on us, Son of David!"

Matthew 9:28

When he had gone indoors, the blind men came to him, and he asked them, "Do you believe that I am able to do this?" "Yes, Lord," they replied.

Matthew 11:5

The blind receive sight, the lame walk, those who have leprosy are cleansed, the deaf hear, the dead are raised, and the good news is proclaimed to the poor.

Matthew 12:22

[Jesus and Beelzebul] Then they brought him a demon-possessed man who was blind and mute, and Jesus healed him, so that he could both talk and see.

Matthew 15:14

Leave them; they are blind guides. If the blind lead the blind, both will fall into a pit."

Matthew 15:30

Great crowds came to him, bringing the lame, the blind, the crippled, the mute and many others, and laid them at his feet; and he healed them.

Matthew 15:31

The people were amazed when they saw the mute speaking, the crippled made well, the lame walking and the blind seeing. And they praised the God of Israel.

Matthew 20:29

[Two Blind Men Receive Sight] As Jesus and his disciples were leaving Jericho, a large crowd followed him.

Matthew 20:30

Two blind men were sitting by the roadside, and when they heard that Jesus was going by, they shouted, "Lord, Son of David, have mercy on us!"

Matthew 21:14

The blind and the lame came to him at the temple, and he healed them.

Matthew 23:16

"Woe to you, blind guides! You say, 'If anyone swears by the temple, it means nothing; but anyone who swears by the gold of the temple is bound by that oath.'

Matthew 23:17

You blind fools! Which is greater: the gold, or the temple that makes the gold sacred?

Matthew 23:19

You blind men! Which is greater: the gift, or the altar that makes the gift sacred?

Matthew 23:24

You blind guides! You strain out a gnat but swallow a camel.

Matthew 23:26

Blind Pharisee! First clean the inside of the cup and dish, and then the outside also will be clean.

Mark 8:22

[Jesus Heals a Blind Man at Bethsaida] They came to Bethsaida, and some people brought a blind man and begged Jesus to touch him.

Mark 8:23

He took the blind man by the hand and led him outside the village. When he had spit on the man's eyes and put his hands on him, Jesus asked, "Do you see anything?"

Mark 10:46

[Blind Bartimaeus Receives His Sight] Then they came to Jericho. As Jesus and his disciples, together with a large crowd, were leaving the city, a blind man, Bartimaeus (which means "son of Timaeus"), was sitting by the roadside begging.

Mark 10:49

Jesus stopped and said, "Call him." So they called to the blind man, "Cheer up! On your feet! He's calling you."

Mark 10:51

"What do you want me to do for you?" Jesus asked him. The blind man said, "Rabbi, I want to see."

Mark 14:65

Then some began to spit at him; they blindfolded him, struck him with their fists, and said, "Prophesy!" And the guards took him and beat him.

Luke 4:18

"The Spirit of the Lord is on me, because he has anointed me to proclaim good news to the poor. He has sent me to proclaim freedom for the prisoners and recovery of sight for the blind, to set the oppressed free,

Luke 6:39

He also told them this parable: "Can the blind lead the blind? Will they not both fall into a pit?

Luke 7:21

At that very time Jesus cured many who had diseases, sicknesses and evil spirits, and gave sight to many who were blind.

Luke 7:22

So he replied to the messengers, "Go back and report to John what you have seen and heard: The blind receive sight, the lame walk, those who

have leprosy are cleansed, the deaf hear, the dead are raised, and the good news is proclaimed to the poor.

Luke 14:13

But when you give a banquet, invite the poor, the crippled, the lame, the blind,

Luke 14:21

"The servant came back and reported this to his master. Then the owner of the house became angry and ordered his servant, 'Go out quickly into the streets and alleys of the town and bring in the poor, the crippled, the blindand the lame.'

Luke 18:35

[A Blind Beggar Receives His Sight] As Jesus approached Jericho, a blind man was sitting by the roadside begging.

In Context | Full Chapter | Other Translations

Luke 22:64

They blindfolded him and demanded, "Prophesy! Who hit you?"

John 5:3

Here a great number of disabled people used to lie—the blind, the lame, the paralyzed.

John 9:1

[Jesus Heals a Man Born Blind] As he went along, he saw a man blind from birth.

John 9:2

His disciples asked him, "Rabbi, who sinned, this man or his parents, that he was born blind?"

John 9:13

[The Pharisees Investigate the Healing] They brought to the Pharisees the man who had been blind.

John 9:17

Then they turned again to the blind man, "What have you to say about him? It was your eyes he opened." The man replied, "He is a prophet."

John 9:18

They still did not believe that he had been blind and had received his sight until they sent for the man's parents.

John 9:19

"Is this your son?" they asked. "Is this the one you say was born blind? How is it that now he can see?"

John 9:20

"We know he is our son," the parents answered, "and we know he was born blind.

John 9:24

A second time they summoned the man who had been blind. "Give glory to God by telling the truth," they said. "We know this man is a sinner."

John 9:25

He replied, "Whether he is a sinner or not, I don't know. One thing I do know. I was blind but now I see!"

John 9:32

Nobody has ever heard of opening the eyes of a man born blind.

John 9:35

[Spiritual Blindness] Jesus heard that they had thrown him out, and when he found him, he said, "Do you believe in the Son of Man?"

John 9:39

Jesus said, "For judgment I have come into this world, so that the blind will see and those who see will become blind."

John 9:40

Some Pharisees who were with him heard him say this and asked, "What? Are we blind too?"

John 9:41

Jesus said, "If you were blind, you would not be guilty of sin; but now that you claim you can see, your guilt remains.

John 10:21

But others said, "These are not the sayings of a man possessed by a demon. Can a demon open the eyes of the blind?"

John 11:37

But some of them said, "Could not he who opened the eyes of the blind man have kept this man from dying?"

John 12:40

"He has blinded their eyes and hardened their hearts, so they can neither see with their eyes, nor understand with their hearts, nor turn—and I would heal them."

Acts 9:9

For three days he was blind, and did not eat or drink anything.

Acts 13:11

Now the hand of the Lord is against you. You are going to be blind for a time, not even able to see the light of the sun." Immediately mist and darkness came over him, and he groped about, seeking someone to lead him by the hand.

Acts 22:11

My companions led me by the hand into Damascus, because the brilliance of the light had blinded me.

Romans 2:19

if you are convinced that you are a guide for the blind, a light for those who are in the dark,

2 Corinthians 4:4

The god of this age has blinded the minds of unbelievers, so that they cannot see the light of the gospel that displays the glory of Christ, who is the image of God.

2 Peter 1:9

But whoever does not have them is nearsighted and blind, forgetting that they have been cleansed from their past sins.

1 John 2:11

But anyone who hates a brother or sister is in the darkness and walks around in the darkness. They do not know where they are going, because the darkness has blinded them.

Revelation 3:17

You say, 'I am rich; I have acquired wealth and do not need a thing.' But you do not realize that you are wretched, pitiful, poor, blind and naked.